In 1963, while working on a book on the Andean Republics, I learned about the pre-Inca earth markings of the Nazca people. I was introduced to Maria Reiche, German mathematician and self-appointed guardian of the mysterious markings of man on the Peruvian plains. She showed me the adventurously obtained, but poor–quality photographs she had taken from the air with her primitive equipment. I listened to her theories about the origins of those markings and her enthusiasm excited me. I arranged a flight with a specially equipped mapping plane, took many color photographs, and sent Reiche some of the prints to assist her in her scientific quest. I never forgot my meeting with her, nor the excitement of that flight over the earth drawings.

In 1976, a young American woman came into my office, showed me her aerial photographs of Nazca and related her encounter with Maria Reiche. This was Marilyn Bridges. I was overwhelmed by her splendid photographs of the drawings and was delighted to hear that Maria Reiche was still protecting the mysterious works and researching their origins.

A few years later, Marilyn Bridges applied for a Guggenheim Fellowship, and I wrote her a letter of recommendation. She received the grant, which helped produce some of the work in this book and exhibition.

Since that time, through her indomitable drive to capture our collective history, she has continued to photograph landscapes marked by the designs of nature and man. Using low angles, dramatic light, and split–second timing, she has created a visual panorama of historic and contemporary sites around the world. Her photographs seek to establish a bond between the past and the present, and reveal the interplay of geography, time, and human invention.

I would like to express my gratitude to Raymond DeMoulin and the Professional Photography Division of Eastman Kodak Company for making this unique project possible. It is through Kodak's generous support that this catalogue, exhibition, and international tour have been realized.

Cornell Capa
Director

"The sky, hitherto considered man's roof, will become his firmament"
— Filippo Tommaso Marinetti

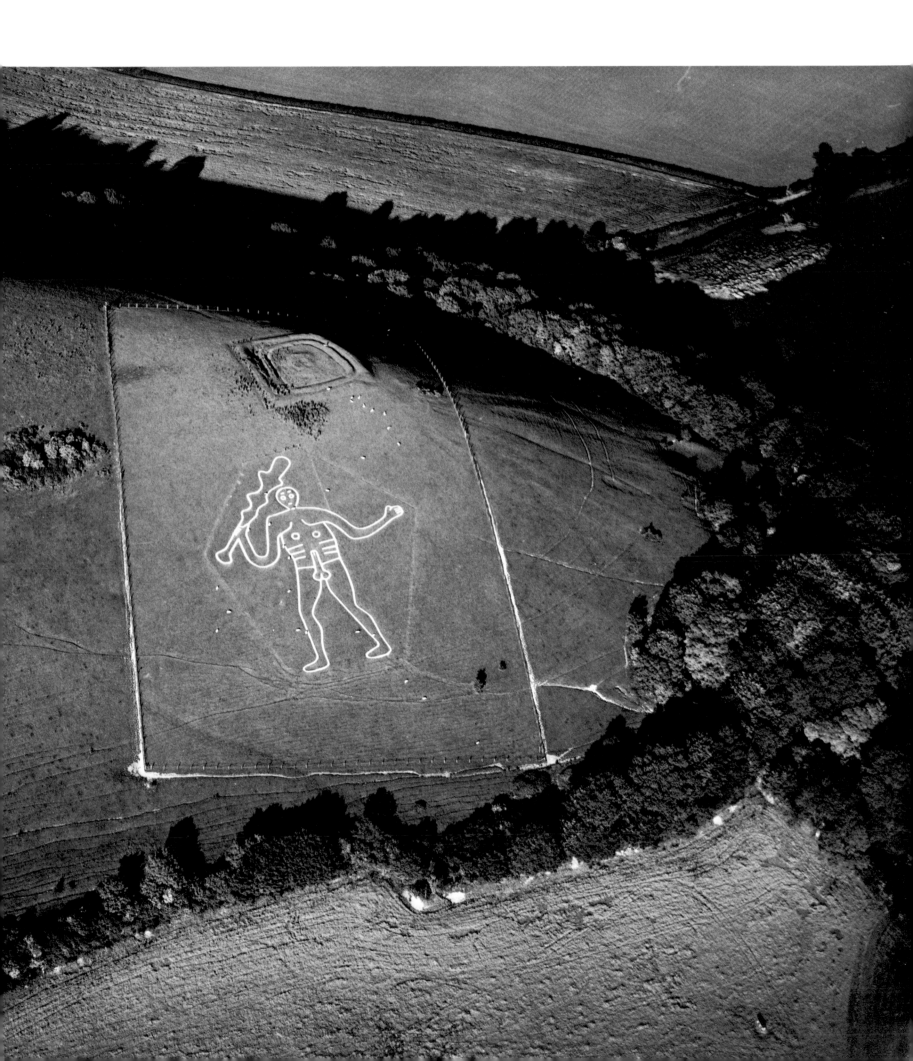

Marilyn Bridges
The Sacred & Secular
A Decade of Aerial Photography
Introduction by Cornell Capa
Essay by Vicki Goldberg
Interview by Anne H. Hoy
Catalog entries by Tom Bridges

cover: Three Pyramids of Giza, Egypt, 1984
frontispiece: Cerne Abbas Giant, Dorset,
England, 1985
back cover: Palm Trees, Miami, Florida, 1987

First published in the USA in 1990 by the
International Center of Photography, 1130
Fifth Avenue, New York City 10128

Library of Congress Catalog Card Number
ISBN No. 0-933642-13-X (softcover)

This catalog is published on the occassion
of the exhibition, "Marilyn Bridges — The
Sacred & Secular," organized by the
International Center of Photography, New
York City. The catalog, exhibition, and
two-year tour are supported by the
Professional Photography Division of
Eastman Kodak Company.

Edited by Anne H. Hoy
Typesetting & composition by Lee Goodman
Printed by The Studley Press,
Dalton, Massachusetts

Catalog & exhibition design by Art Presson

MARILYN BRIDGES

THE
SACRED
&
SECULAR

A DECADE OF AERIAL PHOTOGRAPHY

This Delicate, Patchwork Earth

by Vicki Goldberg

From the vantage point of an angel, the earth must always be beautiful. From Marilyn Bridges's single-engine Cessna, hovering low at the approximate altitude of an angel with wing trouble, the earth tends to be dark, ambiguous, laced with a mournful poetry. The planet's skin is crumpled and worn and scarred with mysterious designs. Someone long ago left signs here, certain they would be recognized: giants and serpents, on a preposterous scale, that stared at the sky unseen till the advent of the airplane. Today the earth's surface is marked with highways and water towers and precisely plowed fields. Serpents, towers, plow marks — they all have a meaning, if only one knows the language.

Bridges's aerial landscapes forge a peculiar bond of intimacy with resistant subjects. Her plane floats closer to earth than photographers tend to fly, usually three hundred to five hundred feet up, where there's little room to maneuver if something goes wrong. High aerial photography, at a thousand feet or more, is wizard with flat abstractions, distance turning the landscape into geometry, but Bridges prefer to coax dimension from the Earth's bumpy surface and fill the frame with clues to a human presence. People live and work on this land or pass through on their journeys; yesterday they came here to propitiate their gods.

Aerial photography has revelled in color for years; Bridges insists on black and white. Her selenium-toned prints are moody and lyrical, with an extensive repertoire of grays. Details flicker out of the shadows, and trees that should be dark may glimmer with a spectral light[1] as if the earth shone dimly back at the sun. "I've always felt that the earth was alive," she says, "that rocks pulsated."[2]

The world represented here at an unsettling slant is charged with contradiction and ambivalence. Buildings threaten to slide out of the frame, jungle vegetation turns dry and fluffy as cotton. In Monument Valley, the black shadows of cliffs stand up stubbornly rather than lying down as proper shadows should (*cat. no. 49*), and in the Badlands, tiny buffalo float across the plain (*cat. no. 52*). Bridges says, "I tilt the camera at a slight downward angle as the plane bows before the subject matter. This position enables me to cheat reality and bend the light."[3] The cheated realities of these landscapes are distant but minutely detailed, deserted yet marked by human hands.

Bridges's planet has led a patchwork existence. Sacred and domestic, nature and culture, past and present jostle each other for space. A medieval tower tops a prehistoric mound within an elegantly tailored English countryside (*p. 24*); trucks must maneuver around crests of sand, windswept over the Pan American Highway in Peru (*p. 31*); fairways and putting greens trail across ancient Native American earthworks in Ohio (*p. 43*). The present dances across the past and constricts the future.

For more than a decade, Bridges has traveled through time, recording sacred sites and unsanctified highways, layers of history that turn the earth's surface into a palimpsest. In 1976, just before entering the Rochester Institute of Technology, she first pointed her camera landward from the air above the Nazca plain in Peru. Once at school, she grew depressed to think she could not afford to photograph such far-off, holy places. (She has been back to Peru eight times since, and discovered earth drawings never before seen by archaeologists.) John Pfahl, who was one of her photography teachers in college, asked her why she didn't just get up in a plane and see what she could see right there in Rochester. She did. Suddenly, over homely, familiar ground, "markings began coming up out of the landscape, the markings that modern-day man was making.... I was getting off on shapes, formations, and geometrics. It was as if the landscape was a huge canvas; I would take sections of it and work with it."

Occasionally those shapes are flat abstractions. Others are unexpectedly droll, like *Tweed Field* (*cat. no. 45*), a plowed corn field that might have come from the carpet department at Bloomingdale's, or the California windmills that look like a chorus line of propellers ready to twirl off into the air (*p. 30*). At Bridges's hovering distance, the land becomes ambiguous: itself and something other. On Miami Beach, the shadows stretch and multiply the palm trees until the beach converts itself into a patterned fabric to wear to a Florida hotel (*cat. no. 57*). (Not until Bridges printed the image did she realize the words *love* and *peace* were written in the sand: "I was meant to take that picture," she says.) When a curator asked her if she had any pictures of baseball diamonds for a show, she said she thought she did, then flew off to find some. The result was a bare field of ghostly graffiti with a few tiny people tacked on, their skinny shadows running down like ink (*p. 42*).

Most of these photographs quietly convey a message about the use and abuse of the earth, about ancient harmonies and modern discord. "The way man treats the earth is the way he treats himself," Bridges says. She believes that long ago people loved the earth, for the land and people were

one, whereas we, having lost that identity, trample our home ground. Indeed, the issues have become so complex that photographs can scarcely contain them. As Lucy Lippard noted in Bridges's book *Markings*, her pictures of Native American monuments raise disturbing questions about venerating the pasts of indigenous people "while we destroy their futures and refuse to respect their present."[4]

Bridges is a product of our time, which is awed by the planet seen from the moon, distressed by the view from the car window, and in need of an accommodation with an environment that will never be innocent again. We have been separated, if not divorced, from the soil so long that it may not be possible to love the landscape unreservedly any more. Although she seldom stands on the ground, Bridges, like Robert Adams, Mark Klett, and other earthbound, contemporary landscape photographers, sees nature and environment as social phenomena, no longer independent of human affairs. The landscape she surveys from an open cargo door is steeped in memories of greatness and besieged by modern times.

▲

Since the Renaissance, artists have tried to imagine the earth from God's point of view. In time, the balloon and the camera combined to provide a slightly more factual approximation than artists had imagined of a landscape everyone knew in a walkabout way but no one had ever seen *in extenso*. Nadar did it first, carrying his camera over a suburb of Paris in 1856 and casting his coat and shoes to the wind in hopes his balloon would rise higher. Two years later, James Wallace Black did it better from twelve hundred feet above Boston's roofs. The eye had been released from earthly limitations; naturally enough, the mind was puzzled. An early view of the Ile de la Cité in Paris was so unnervingly unfamiliar that people refused to trust it until comparison was made to a detailed map. Still, it did not take long to realize how useful the new power of vision could be. Military men soon made plans to send spying lenses aloft on balloons or kites, and in 1903, a patent was taken out on a camera for pigeons, making the term "bird's-eye view" more than a little redundant.

Once the airplane flew in, aerial photography proved itself a master of discovery: during World War I, a pilot flying over Iraq brought back evidence of ancient sites hidden for centuries from the view of those on earth.[5] To artists, the aerial view seemed to be emblematic of a new age. Robert Delaunay painted the Eiffel Tower after a photograph taken from a balloon; Alvin Langdon Coburn settled for a skyscraper, then looked down on the sidewalks of New York.

The flying aces of World War I and their dramatic dogfights intensified the public romance with flight even as aerial reconnaissance photography proved itself indispensable to modern warfare. Aesthetic fascination with aerial views increased to the point where artists and photographers considered them a key to the reinvention of vision. Malevich painted abstractions

of flight; Rodchenko, Moholy-Nagy, Kertész, and dozens of other photographers positioned themselves atop buildings and towers and snapped vertiginous views. But in the late thirties, even as Bradford Washburn was pioneering aerial photography of mountains, the first bombing attacks on civilian centers in Spain were dimming the luster of the view from above as a utopian, ideal vision.

By the fifties, a steady expansion of commercial air flights began to reveal to ordinary travelers a land that looked like modern paintings. In 1950, Margaret Bourke-White photographed American cities and beaches from a helicopter and turned them into handsomely redesigned versions of themselves; from a plane in 1955, she transformed farmlands into rigorous abstractions in color. In the following decades, two men would dominate the field of aerial photography as an art form: Georg Gerster and William Garnett. Both of them, but Gerster especially, flew high enough to turn the incidents of earth into startling, beautiful, flat patterns in daring color, often so transfigured by distance that only a caption could identify them. Then in the sixties and seventies, photographs from space lifted public interest and emotional response to a new high: the heart leaped at the news of other planets vouchsafed from the longest view.

But if outer space had reported home, there were not so many artistic enterprises at the lower altitudes in 1976 when Marilyn Bridges first peered out the open door of a plane. Bridges says she was aware of a limited amount of aerial photography. She had also seen "horrible survey photos," flat slices of some monotonous map of the world; they taught her what she did not want to do.

▲

Marilyn Bridges grew up in a New Jersey suburb. Her mother, who went to art school before she married, encouraged her to dance and draw, whatever artistic activity she liked, convincing her early on that the things she wanted to do in life could all be done. Her father's hobby was photography; he gave her a camera when she was five and often asked her to sit for hours for her portrait. He also trained her to handle fear when she was still quite small. Spiders frightened her, and once when she thought she had been bitten, she was convinced she was going to die. Her father said, "Marilyn, you're going to learn about spiders," and began to instruct her. Soon she had book after book on spiders. "He taught me to go into the fear rather than pull away from it. Fear in a way is an illusion, anticipating something you think will happen in the future rather than what's happening in the present."

From the youngest age she can remember, Bridges would lie on a huge boulder she called "the magic rock" outside her house, feeling life hidden in the rock, certain there were people living inside it. She used to take sticks from the forests all around and make arrangements and markings in the earth, delighting in the kinds of changes she could produce on the land's

surface. "It was like putting myself into the earth," she says; sometimes she invited friends by to see what she had done. These memories have only returned in the last few years as she followed the marks of humankind across the world.

At the proper time in New Jersey, Bridges made her debut — and didn't like it. She remembers reading in LIFE about hippies in Haight-Ashbury, whose capacity for self-expression with clothes, hair, music, and dance struck her as a kind of artistic freedom. "I was hungry to learn about life. That seemed like a place to learn about the parts of it I hadn't learned about in Bergen County." She bought a plane ticket, left home, and flew to San Francisco. It was to be the first of many times she would fly off to another culture.

After a few months, Bridges came East again, got married, studied art and philosophy at a community college and painting and drawing at the Art Students League. Her husband worked for a travel magazine; on his return from one trip, he handed her a camera and said, "Okay, now you're going to be the photographer." So she traveled with him, convinced that the world would educate her better than any school. In no time she had a career. She says she has always changed very quickly, both in her emotions and in her ideas of what she would do with her life. Photography was so much faster than painting, it suited her perfectly: "I love it happening in an instant so that all that emotion is packed into a moment."

She first tried her hand at aerial photography in 1976, when she was in Peru photographing a travel story. The Nazca lines, discovered by fliers scarcely fifty years earlier, had been made famous by Erich von Daniken's theory that they were runways for extraterrestrials. No one is certain just what the lines and figures signify, although some clearly mark astronomical times and directions. Too large to be fully comprehended from the ground, they unmistakably reflect an advanced and creative culture. Perhaps they were meant for the gods — but given to us by the invention of propellers.

When Bridges hired her first plane, the Peruvians immediately removed a door to widen her view. Seeing nothing but a flimsy seat belt to tie her in, she grew nervous; the pilot took his belt off and fastened it around her. "I was moving between fear and excitement constantly," she says. "Every time he'd tilt the plane I'd be sure I'd slip out. At the same time what I was seeing was so fantastic.… My first thoughts were, my God, I'm really seeing a miracle here. I knew they were made for a higher purpose, whatever that was." She adds that she had had spiritual experiences before she saw Nazca and was strongly drawn to sacred sites.

Shooting the Nazca lines changed her life. On travel assignments she had been taking color pictures, but after her first flight she switched to black and white and never turned back. Nazca also diverted her from commercial photography and set her on her course across the sky. Groping for what she was supposed to do, as she puts it, she left the marriage that year, and devoted herself to photography. (A second marriage, to a photographer and instructor at the Rochester Institute of Technology, would break up partly because she was away so often working.) She entered RIT in the fall with a

sheaf of Peruvian negatives that she printed as her first school project. The negatives were so thin that she had to make internegatives and print in the elegant, time-consuming Van Dyke Brown process popular at the turn of the century. But the deep shadows, taut longing, and sense of time standing unnaturally still that mark her work were present in every print. Bridges already had her style. Cornell Capa saw that work and admired it, and the Museum of Natural History in New York gave her an exhibition.

She meant to study aerial photography at RIT, but not one course was offered. An instructor of industrial photography who had done some aerial surveillance in the military took her to the windy heights of one of Rochester's few hills and set up test after test. At last she went aloft, over and over until she could make it work. Already she wanted to be intimate with the distant land, but she could not get the pilot to fly as low as she liked. She used to beg pilots to go lower, lower — in time she would make it a condition of the flight before she agreed to go up. She still wants to fly slowly, too; even with Tri-X film and a high-speed setting, the land goes by too fast. (Bridges uses a 6x7 Pentax — a medium-format camera — and sometimes a Leica, and pushes her film.) The plane is often enough on the brink of stalling. Bridges says she likes being challenged in life, likes a new stimulus to see how she reacts to it: "That's what makes me feel really alive."

At RIT she studied photography, archaeology, and language, earning her bachelor's degree in 1979 and master of fine arts in 1981. (She put herself through school on scholarships, loans, and jobs as a Playboy bunny and fashion model.) One year later she won a Guggenheim Fellowship. (Since then she has had National Endowment for the Arts and New York State grants, a Fulbright, and support from Kodak.) On the Guggenheim grant, she flew from upstate New York to the Yucatán. It was a harrowing trip over a sea of jungle unmarked by roads or clearings. They were often lost, and both she and the pilot knew that if they went down, the jungle was likely to swallow them forever. Though she had never been in a pilot's seat, he insisted she take the controls while he looked at the map. "You learn quickly," she says, "when you know if you don't, you may never get to your destination."

When she got back, Bridges took flying lessons to face her fear — "in a little plane, it's very fragile, it's just like being encased in a piece of *fabric*" — earned a license, and eventually bought her own Cessna. She still has a pilot fly the plane so she can give all her energies to photographing, but she knows what the craft can do. Danger remains part of the game. In Peru, the pilot would insist that the mechanic who worked on the craft go up with them, as insurance. Should they go down in an isolated area, repairs had better be fast; the only people anywhere nearby were likely to be terrorists. At Machu Picchu, the altitude was so high the pilot had to use oxygen, but Bridges was too busy. She lay flat and hung out of the door while an archaeologist held her ankles; she says that the air washing in constantly revived her. Her photographs of Machu Picchu and the Yucatán picture a forlorn and bewildering grandeur. The great ruins and stepped platforms abruptly punctuate jungle that seems merely to be biding its time before devouring all signs of history.

On an NEA grant Bridges flew over Stonehenge at dawn, when sun burned on the stone and the mighty circle looked like a toy idly cast down by a race of giants (*p. 21*). She usually prefers to fly at twilight to catch the lengthening shadows and the light playing tricks with dimension. (Stonehenge is near a military rifle range; the only time she could get permission to fly was before the soldiers came out for practice.) In the desert haze of Peru and Egypt, Bridges has flown at noon and brought back pale images, more like drawings than photographs, of cities drowning in the sand, of pyramids with a tenuous hold on solidity (*p. 39 and cat. no. 18*). In Britain she traced the Uffington Horse (*p. 15*), so perfect a landmark the British had to paint and plant over it in World War II to mislead German planes; and the Cerne Abbas Giant (*frontispiece*), so potent a symbol of fertility that modern couples have been known to make love atop it.

She has pursued the holy remnants of Native American cultures whenever she had the chance, from the mound across the street from a driveway in Newark, Ohio (*cat. no. 36*) to the enormous figure of a woman near Blythe, California (*p. 19*), which was given male genitals by Boy Scouts sent to tend it, then adorned with spiralling patterns about its arms and head by dune buggies on a spree. Barbara Morgan told her that when she was young she walked the serpent mound in Ohio and ceased to be Barbara Morgan: for a time, she became the serpent itself. Bridges agrees that the place is powerful; after she photographed it, she dreamed of flying with the serpent.

▲

Much of this native heritage is ignored and endangered; so too is the land. Bridges's message about the delicate earth begins to grow more explicit in a few images of dark, spreading highways and cut-up countryside. (Whether our dreary asphalt enterprise will yield an equivalent mystery remains to be seen; Bridges has recently begun to photograph chemical plants and clear-cut logging operations.) *If You Smoke* (*p. 59*) is a paved-over conduit, a place to pass through on the way to someplace else. As in the urbanscapes of the twenties and thirties by Ralph Steiner and Walker Evans, where advertisements defined the times and hinted of human desire, a billboard winks at us from the ground, adding a touch of irony to a vale of fumes.

North America's secular formations, like banded railroad tracks and toll booths, are as symbolic as the birds of the Nazca plateau. We still perform rituals, some tied to seasons, though the rites seem not to be religious; we still propitiate our gods, all unaware who or what they are; still arrange the earth's surface to bear witness to our presence. Who knows what future culture will fly over the tracks and swimming pools, concrete strips and storage tanks we leave behind and wonder what spirits we were trying to signal, and what we were trying to say?

1 The unnaturally light trees are the product of a yellow filter.

2 Marilyn Bridges, interview with Vicki Goldberg, March 18, 1990. Unless otherwise noted, all Bridges's quotes and opinions come from this interview or from an interview on April 6, 1990.

3 Marilyn Bridges: *Markings: Aerial Views of Sacred Landscapes* (New York: Aperture, 1986), p. 56.

4 *Markings*, p. 59.

5 For a brief history of aerial photography, see Beaumont Newhall, *Airborne Camera: The World from the Air and Outer Space* (New York: Hastings House, 1969). Newhall commented on the photograph of the Ile de la Cité in a lecture at the New York Public Library on April 7, 1988.

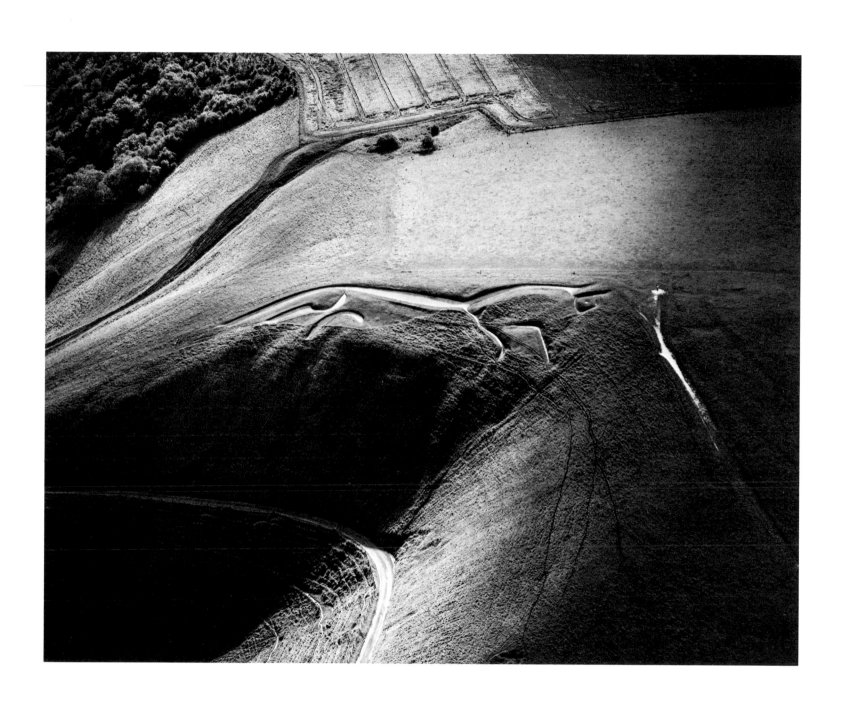

Uffington Horse
Oxfordshire, England, 1985, *cat. no. 29*

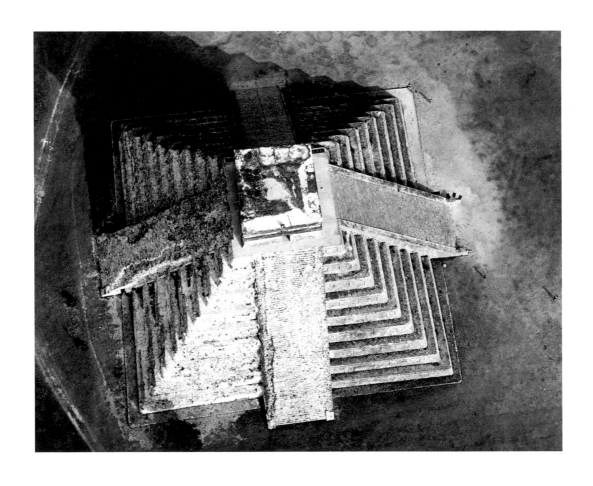

Castillo from the Perpendicular
Chichén Itzá, Yucatán, Mexico, 1982, *cat. no. 14*

THE CENTER FOR CREATIVE PHOTOGRAPHY

The University of Arizona • Tucson, Arizona 85721-0103

(520) 621-7968 phone, (520) 621-9444 fax, website: www.creativephotography.org

ccp.arizona.edu/ccp.html
click on collections

SELECTIVE LIST OF PHOTOGRAPHERS IN THE COLLECTION

Ansel Adams
Lola Alvarez Bravo
Manuel Alvarez Bravo
Paul L. Anderson
Diane Arbus
Dick Arentz
Richard Avedon
Herbert Bayer
Louis Carlos Bernal
Ruth Bernhard
Ernest Bloch
Karl Blossfeldt
Howard Bond
Félix Bonfils
Edouard Boubat
Alice Boughton
Brassaï
Josef Breitenbach
Anne Brigman
Dean Brown
Anton Bruehl
Francis J. Bruguière
Wynn Bullock
Marsha Burns
Debbie Fleming Caffery
Harry Callahan
Jo Ann Callis
Morrie Camhi
Paul Caponigro
Manuel Carrillo
Henri Cartier-Bresson
William Christenberry
Larry Clark
Lucien Clergue
Alvin Langdon Coburn
Van Deren Coke
Linda Connor
Barbara Crane
Imogen Cunningham
Edward S. Curtis
Louise Dahl-Wolfe
Judy Dater
Bruce Davidson
Joe Deal
Roy DeCarava
Peter DeLory
Adolf De Meyer
Robert Doisneau
Jim Dow
Harold Edgerton
Elliott Erwitt
Walker Evans
Adolf Fassbender
Andreas Feininger

Robert Fichter
George Fiske
Robbert Flick
Robert Frank
Gisèle Freund
Lee Friedlander
Francis Frith
Oliver Gagliani
Flor Garduño
Paolo Gasparini
Arnold Gassan
Arnold Genthe
Ralph Gibson
Laura Gilpin
Judith Golden
Emmet Gowin
Jan Groover
John Gutmann
Otto Hagel
Johan Hagemeyer
Betty Hahn
Charles Harbutt
Robert Heinecken
Fritz Henle
Florence Henri
Abigail Heyman
Gary Higgins
Eikoh Hosoe
Graciela Iturbide
Joseph Jachna
Harold Jones
Pirkle Jones
Fritz Kaeser
Yousuf Karsh
Ron Kelley
André Kertèsz
Chris Killip
Mark Klett
Dorothea Lange
William Larson
Jacques-Henri Lartigue
Clarence John Laughlin
Russell Lee
David Levinthal
George Platt Lynes
Danny Lyon
Joan Lyons
Man Ray
Mike Mandel
Margrethe Mather
Lawrence McFarland
Dick McGraw
Pedro Meyer
Joel Meyerowitz

Duane Michals
Hansel Mieth
Tom Millea
Roger Minick
Arno Rafael Minkkinen
Richard Misrach
Kozo Miyoshi
Lisette Model
Barbara Morgan
Earl H. Morris
Wright Morris
William Mortensen
Stefan Moses
Frances Murray
Eadweard Muybridge
Joan Myers
Joyce Neimanas
Esta Nesbitt
Bea Nettles
Beaumont Newhall
Arnold Newman
Dorothy Norman
Kenda North
Sonya Noskowiak
Timothy O'Sullivan
Bill Owens
Marion Palfi
Ann Parker
Mitchell Payne
John Pfahl
Bernard Plossu
David Plowden
James Pomeroy
Eliot Porter
Charles Pratt
Doug Prince
Linda Rich
Arthur Rothstein
Meridel Rubenstein
Philippe Salaün
Jesús Sánchez Uribe
August Sander
Naomi Savage
John Sexton
David Seymour (Chim)
Ben Shahn
Charles Sheeler
Stephen Shore
Ann Simmons-Myers
Aaron Siskind
Neal Slavin
Henry Holmes Smith
Keith Smith
W. Eugene Smith

Rosalind Solomon
Frederick Sommer
Giorgio Sommer
Albert Sands Southworth
Stephen Sprague
Edward Steichen
Ralph Steiner
Alfred Stieglitz
Dennis Stock
Lou Stoumen
Paul Strand
Karl Struss
Jean-Pierre Sudre
Edmund Teske
John Thomson
George A. Tice
Charles Traub
Arthur Tress
Jerry Uelsmann
Umbo
Burk Uzzle
James Van Der Zee
Willard Van Dyke
David Vestal
Laura Volkerding
Adam Clark Vroman
Todd Walker
Bradford Washburn
Carleton E. Watkins
Todd Webb
Weegee
Jack Welpott
Eudora Welty
Brett Weston
Edward Weston
Minor White
Garry Winogrand
Marion Post Wolcott
Don Worth
Mariana Yampolsky
Max Yavno
Ylla
C. and G. Zangaki

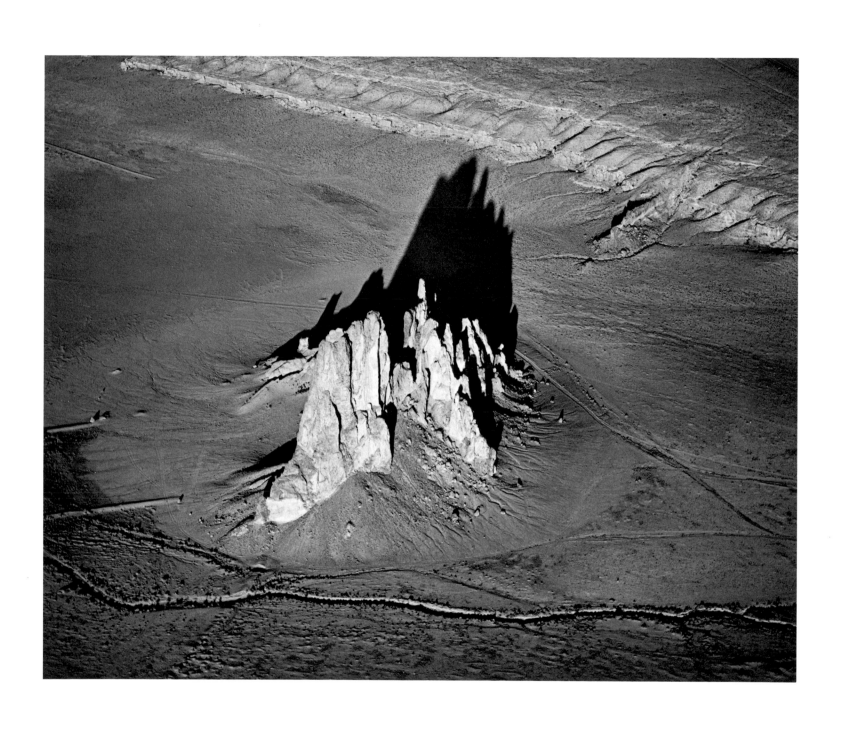

Spires, Monument Valley
Arizona/Utah, 1983, *cat. no. 51*

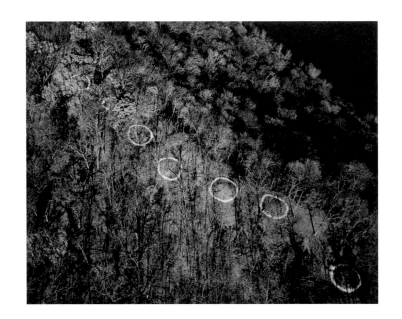

above, Conical Mounds
Iowa, 1983, *cat. no. 39*

right, Ha-ak, Blythe Site #1
California, 1982, *cat. no. 34*

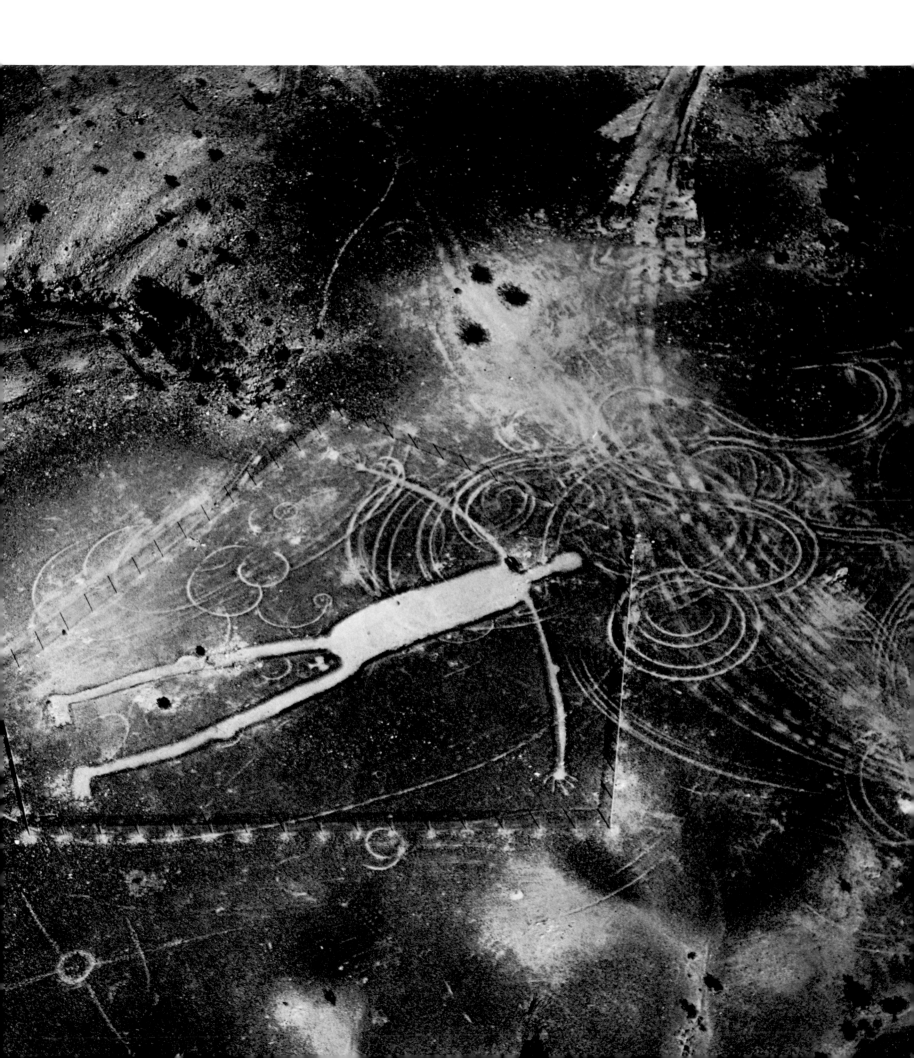

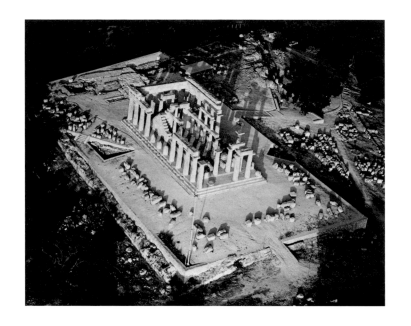

Aphaia Temple
Aegina, Greece, 1984, *cat. no. 22*

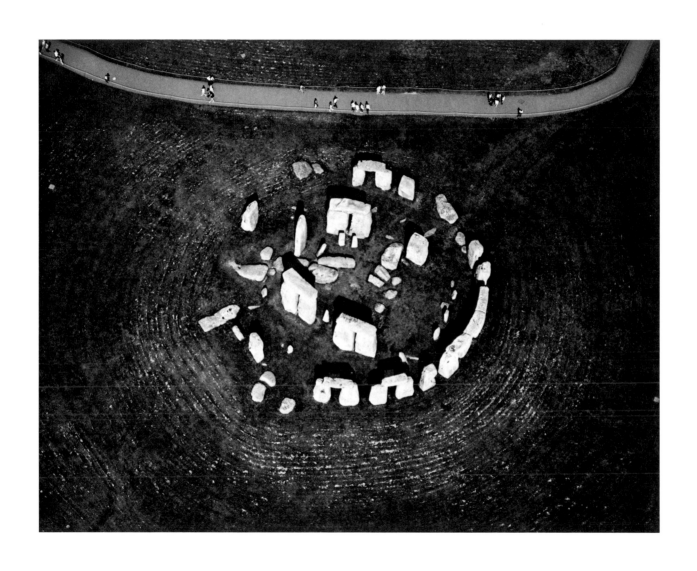

Stonehenge #1
Wiltshire, England, 1985, *cat. no. 33*

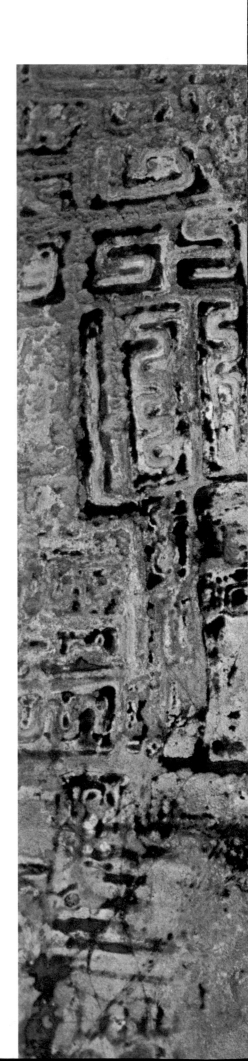

above, Swirl
Mount St. Helens, Washington, 1981, *cat. no. 55*

right, Ancient Irrigation (computer tapestry)
mid-North Coast, Peru, 1989, *cat. no. 10*

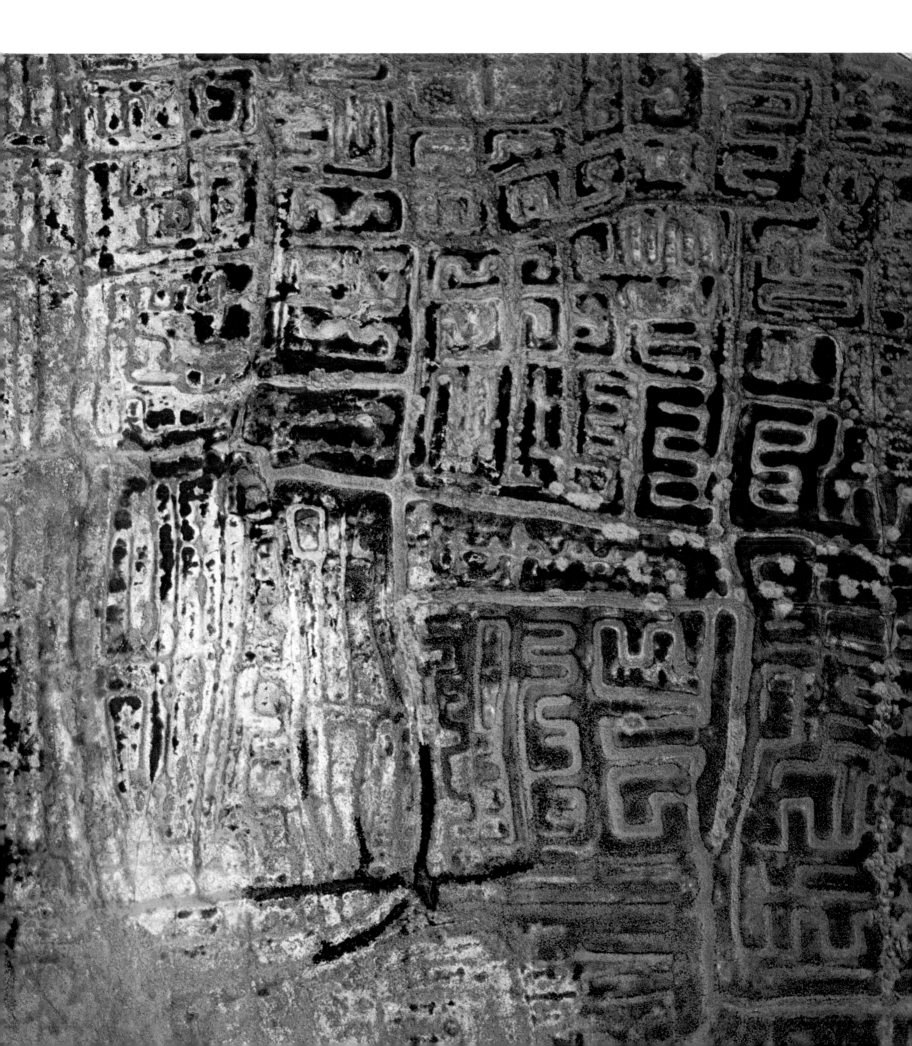

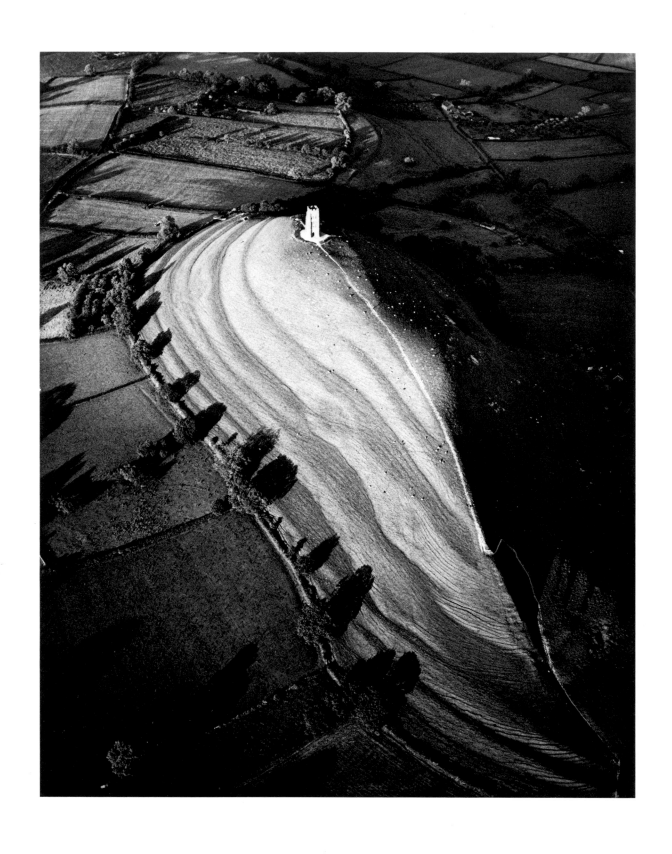

above, Glastonbury Tor
Somerset, England, 1985, *cat. no. 30*

right, Pathway to Infinity, high overview
Nazca, Peru, 1988, *cat. no. 11*

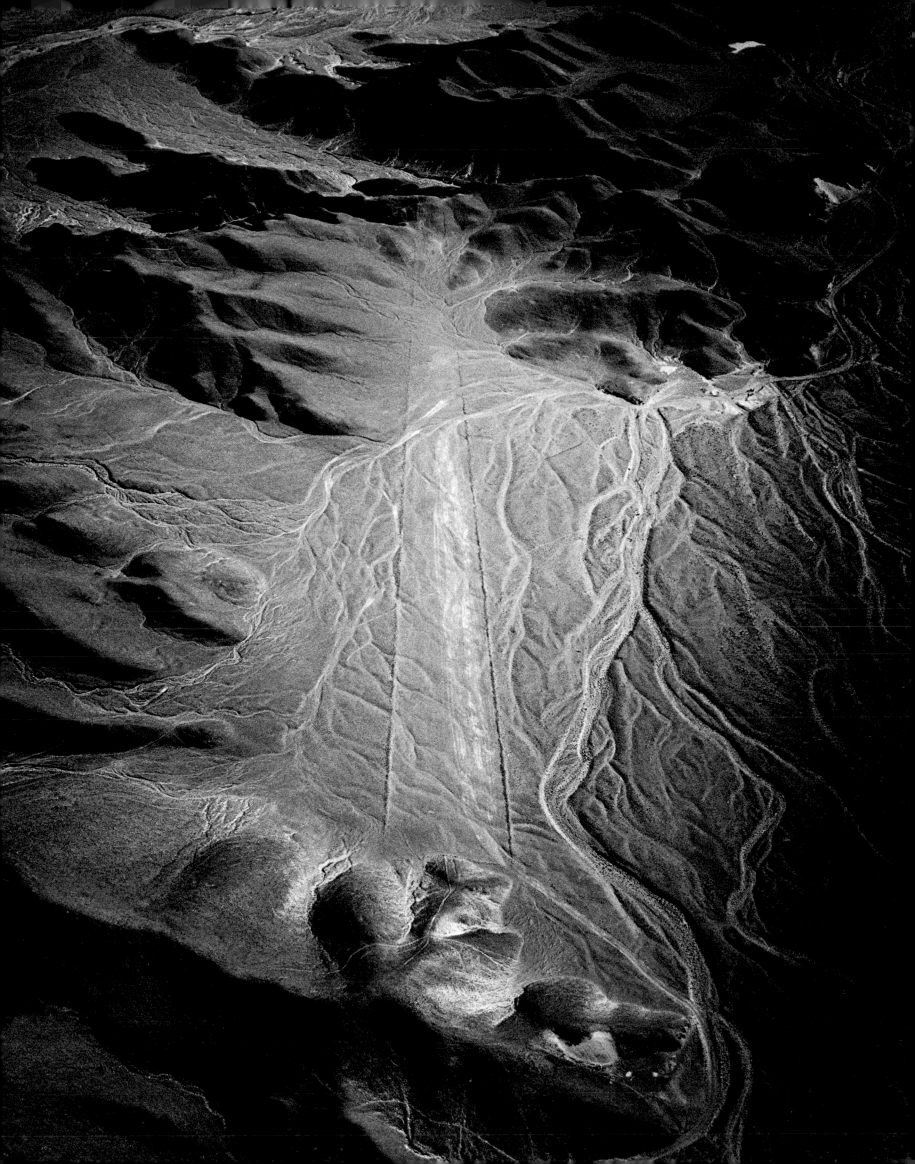

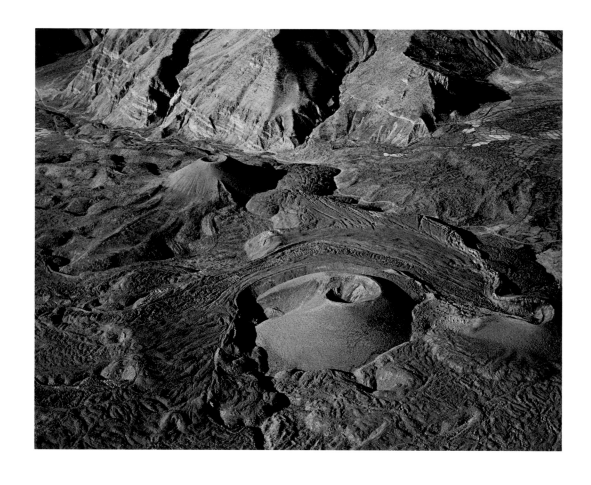

above, Valley of the Volcanos
Andagua, Peru, 1989, *cat. no. 6*

right, Great Inca Wall
Santa Valley, Peru, 1989, *cat. no. 8*

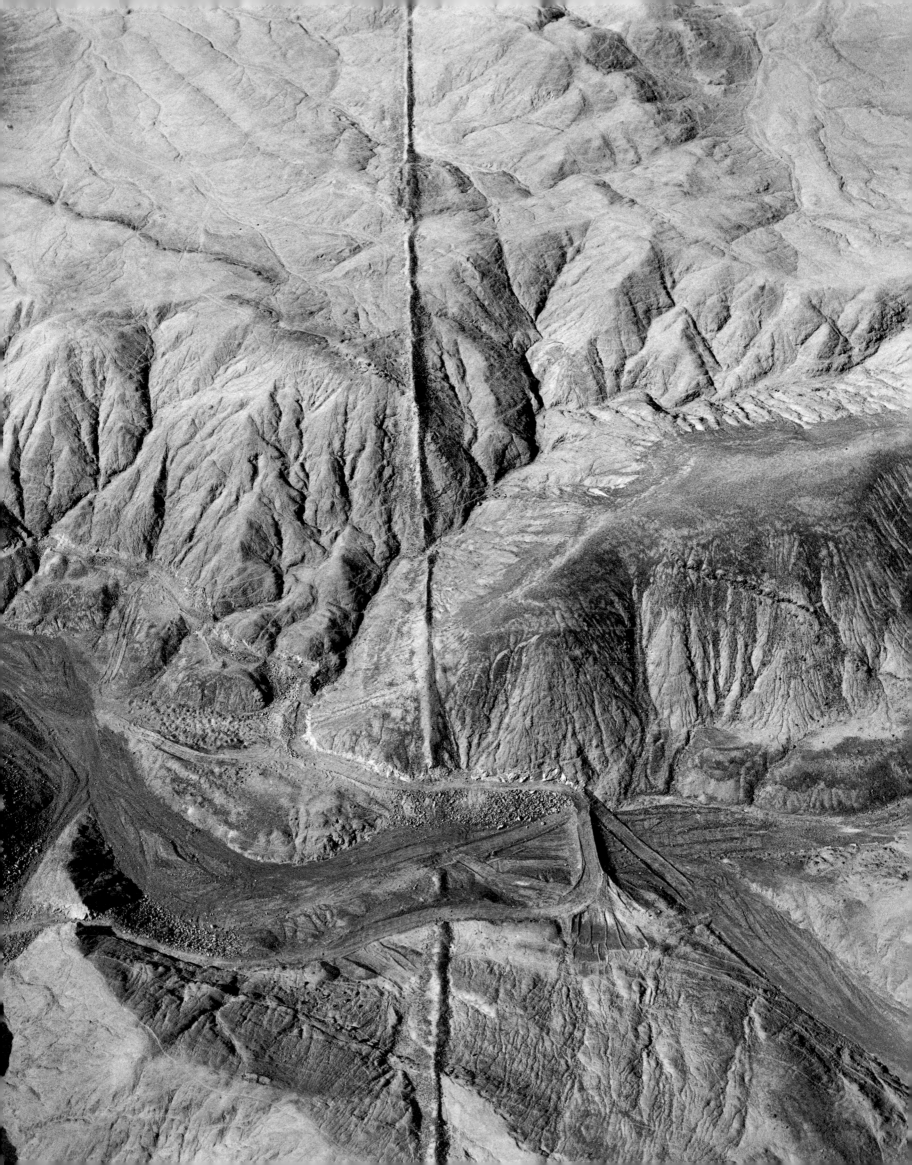

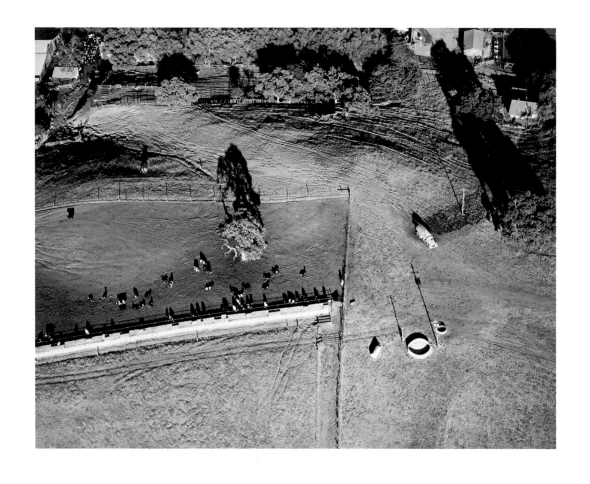

Feeding Cattle
Petaluma, California, 1986, *cat. no. 42*

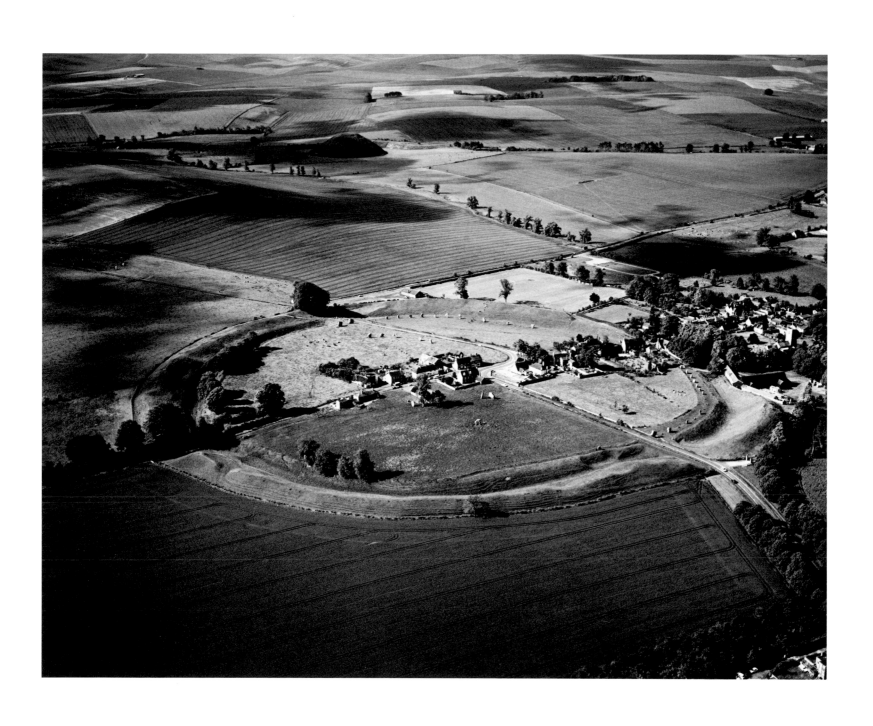

Avebury with Silbury Hill
Wiltshire, England, 1985, *cat. no. 32*

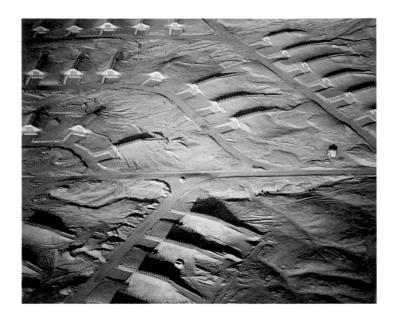

Desert Military Installation
Ica, Peru, 1989, *cat. no. 2*

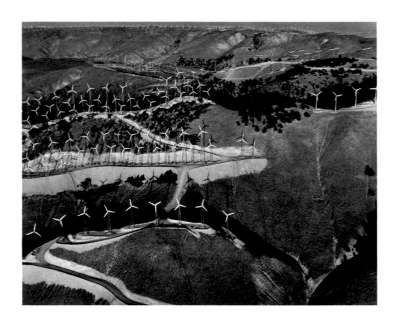

Windmills on Ridges
Tehachapi, California, 1986, *cat. no. 56*

Circles Along the Hudson
New York City, 1985, *cat. no. 62*

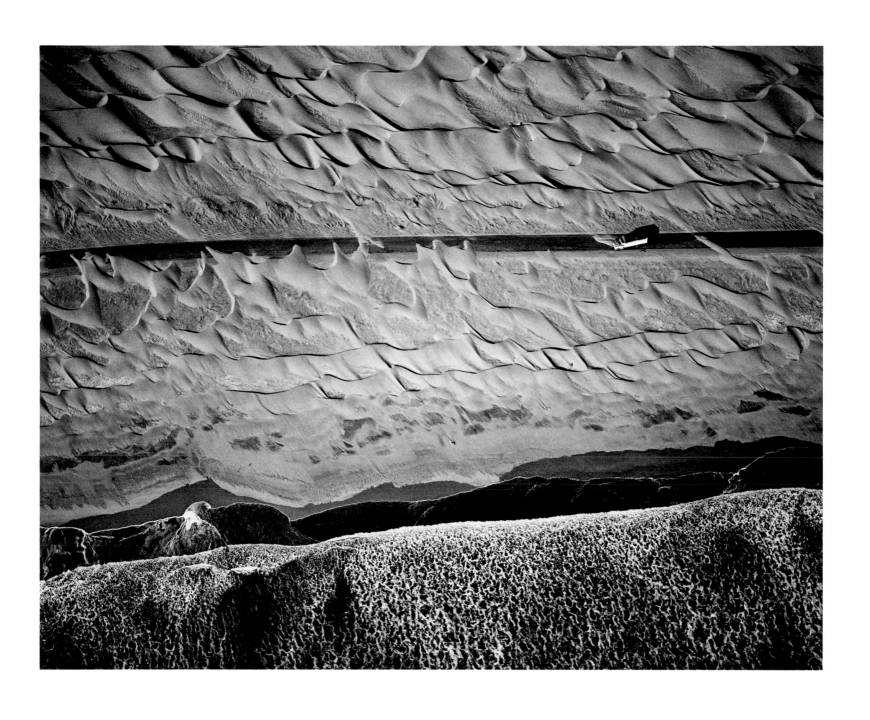

Sand Dunes with Truck on Coastal Pan American Highway
near Chala, Peru, 1989, *cat. no. 12*

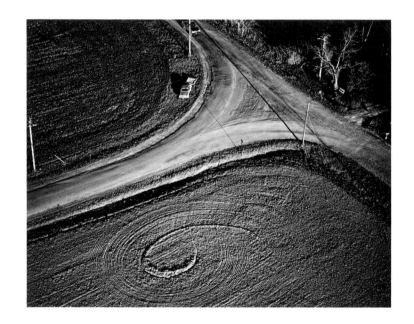

above, Road
Avon, New York, 1980, *cat. no. 46*

right, Cattle Trails
Quartz Mountain, Oklahoma, 1987, *cat. no. 53*

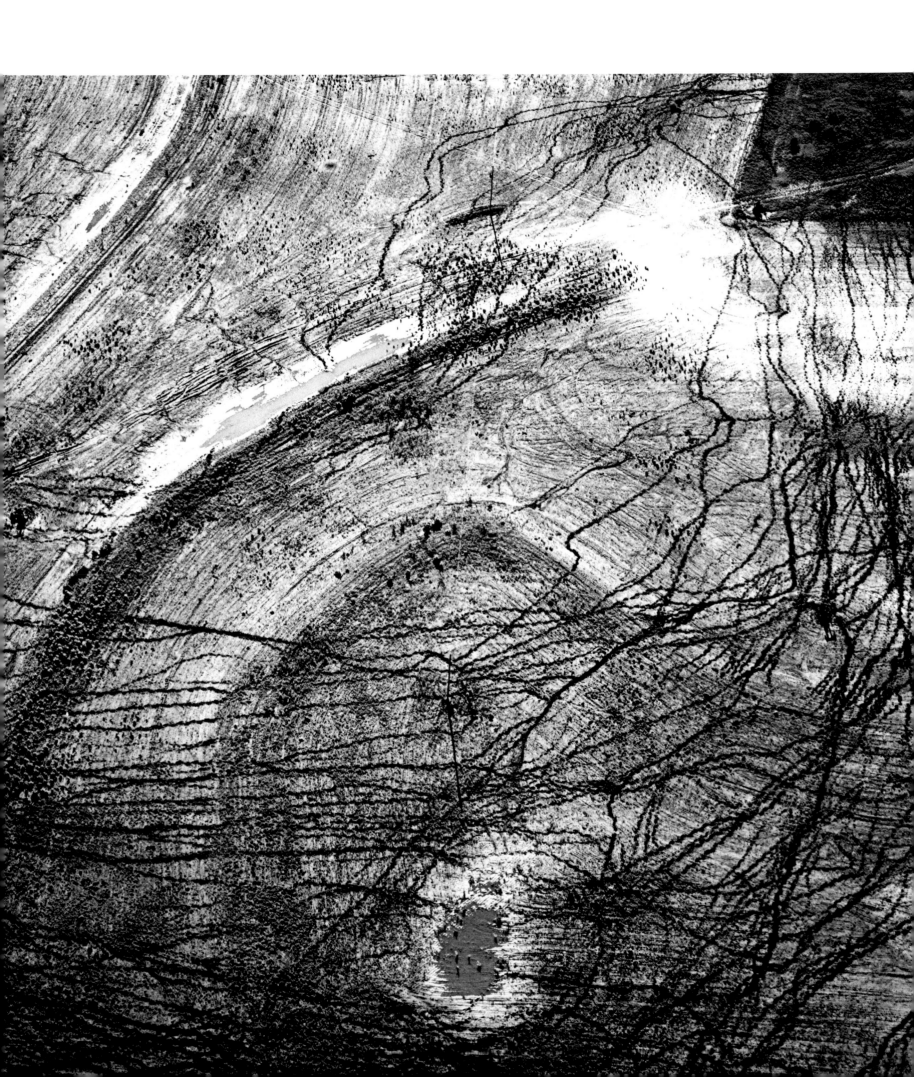

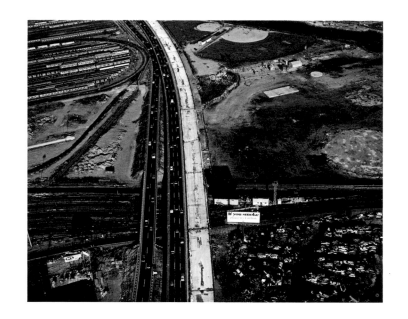

above, If You Smoke
New York City, 1985, *cat. no. 59*

right, Parker Rattlesnake
Parker, Arizona, 1983, *cat. no. 35*

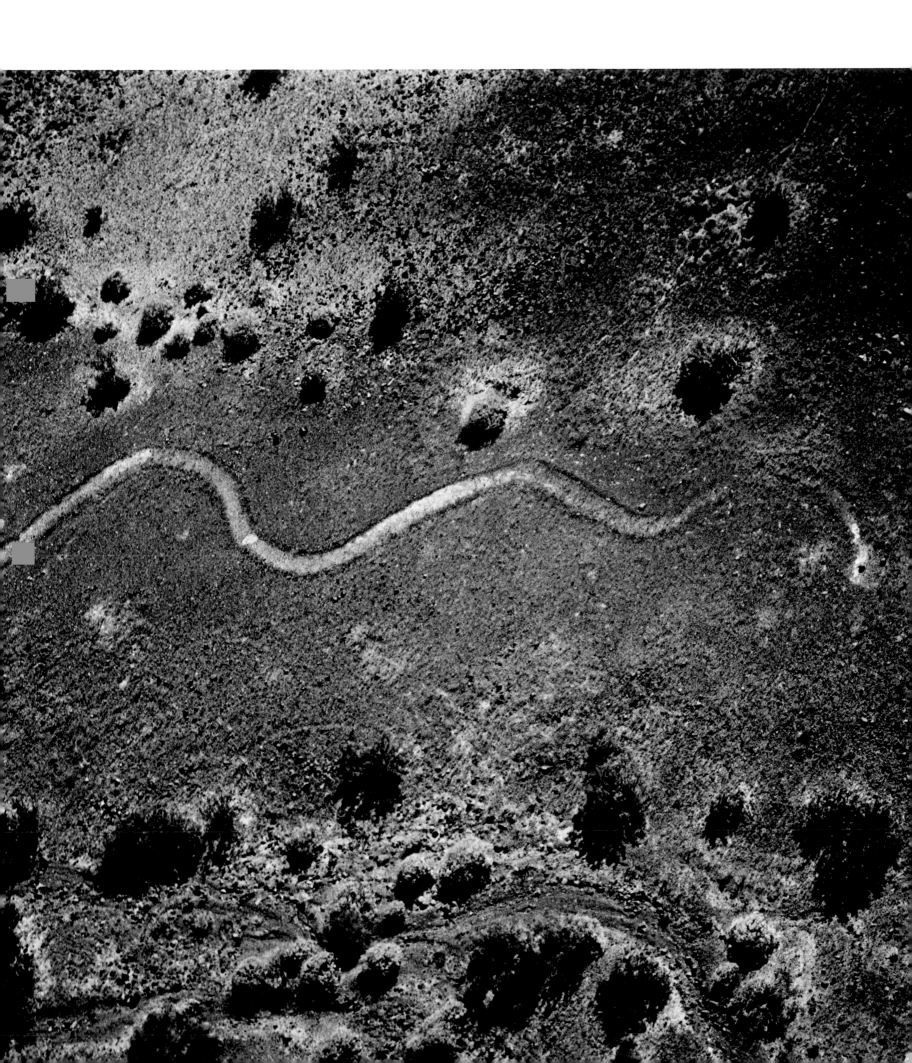

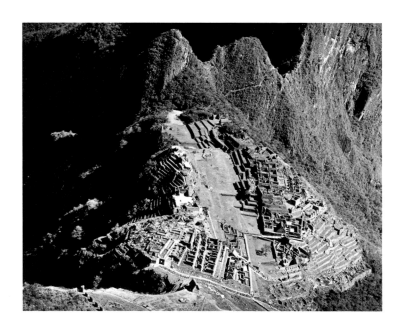

Machu Picchu (with Huayna Picchu)
Peru, 1989, *cat. no.7*

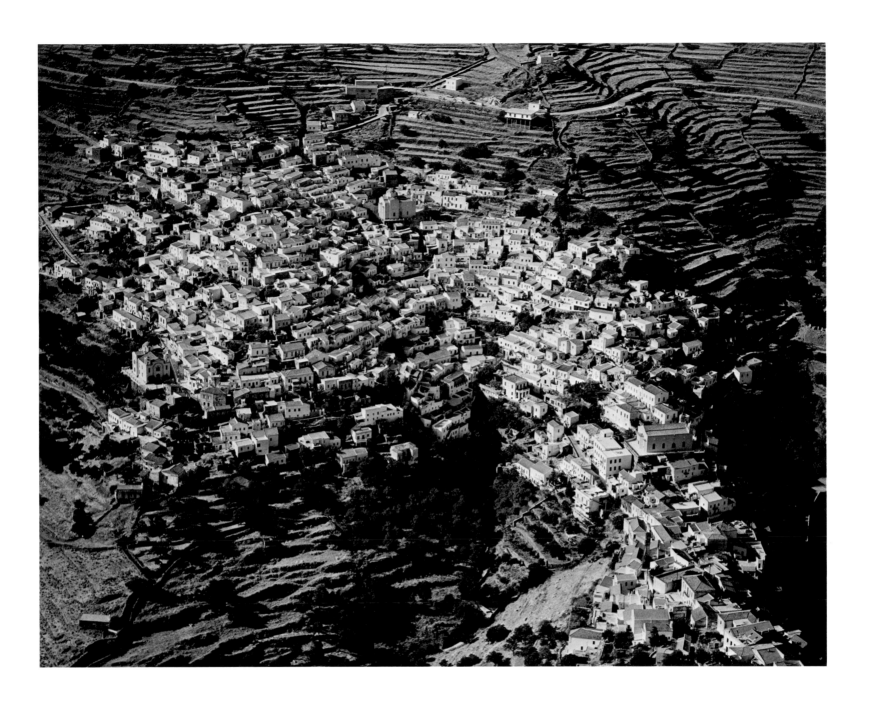

White City
Kea, Greece, 1984, *cat. no. 23*

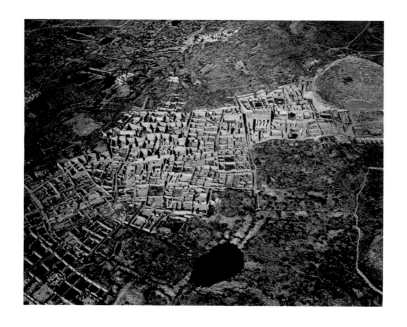

Theatre and Sanctuaries of the Foreign Gods,
Delos, Greece, 1984, *cat. no. 26*

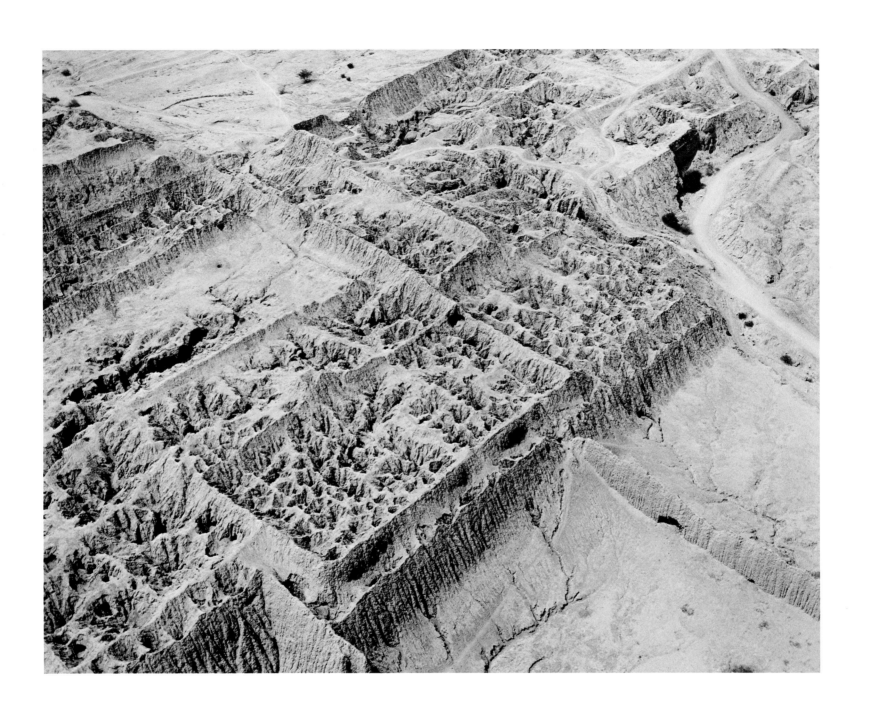

Cerro Purgatorio
Leche River Valley, Peru, 1988, *cat. no. 4*

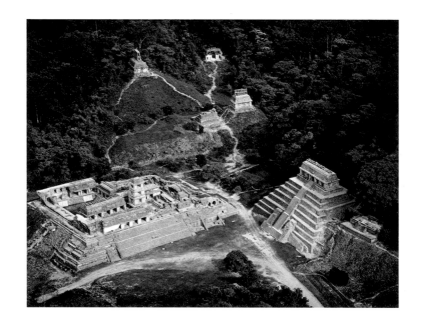

Overview, Palenque
Chiapas, Mexico, 1982, *cat. no. 16*

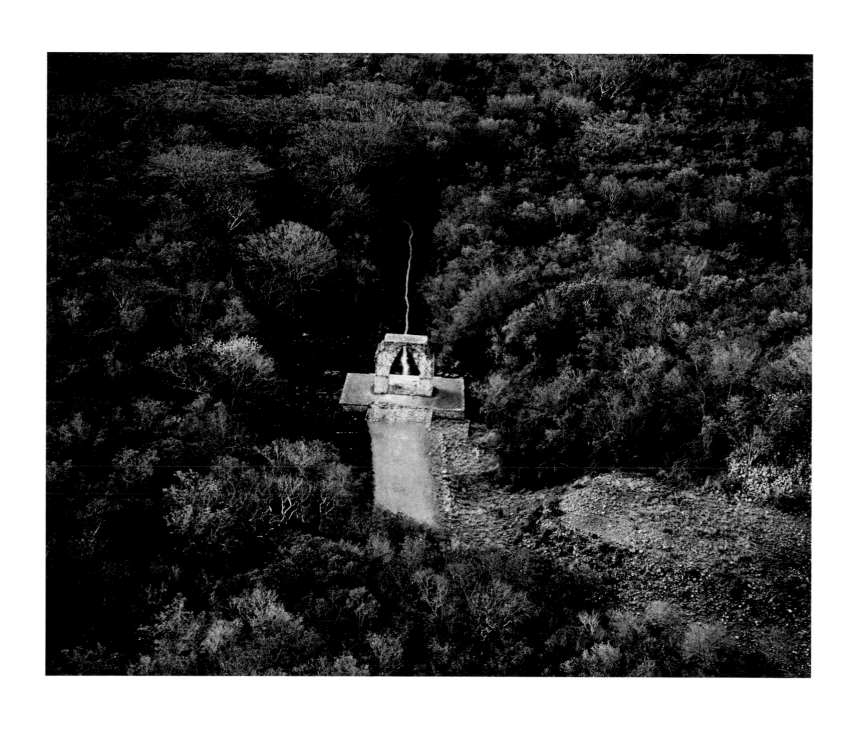

Archway, Kabáh
Yucatán, Mexico, 1982, *cat. no. 13*

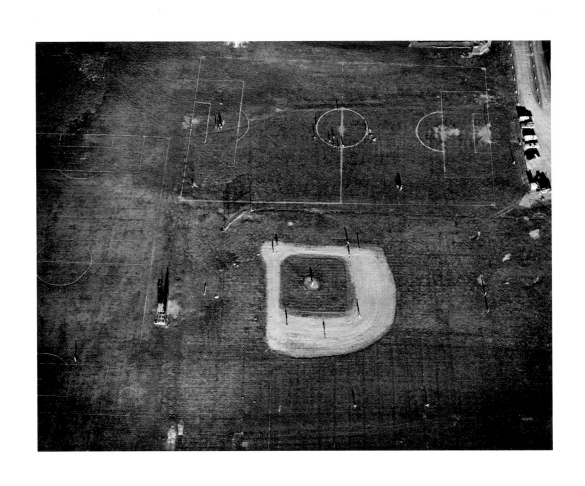

Playing Baseball
Allens Creek, New York, 1986, *cat. no. 43*

Newark Earthworks, High Overview
Ohio, 1983, *cat. no. 38*

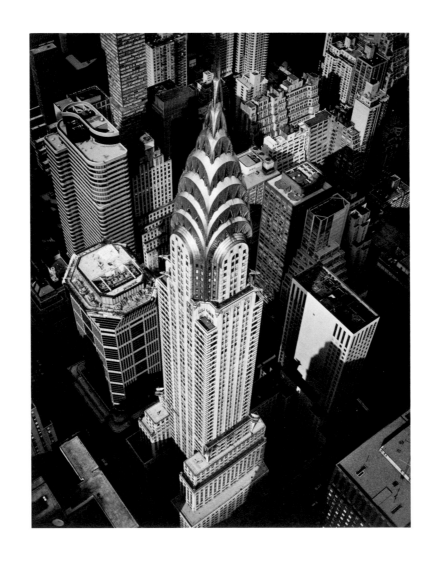

Chrysler Building
New York City, 1988, *cat. no. 58*

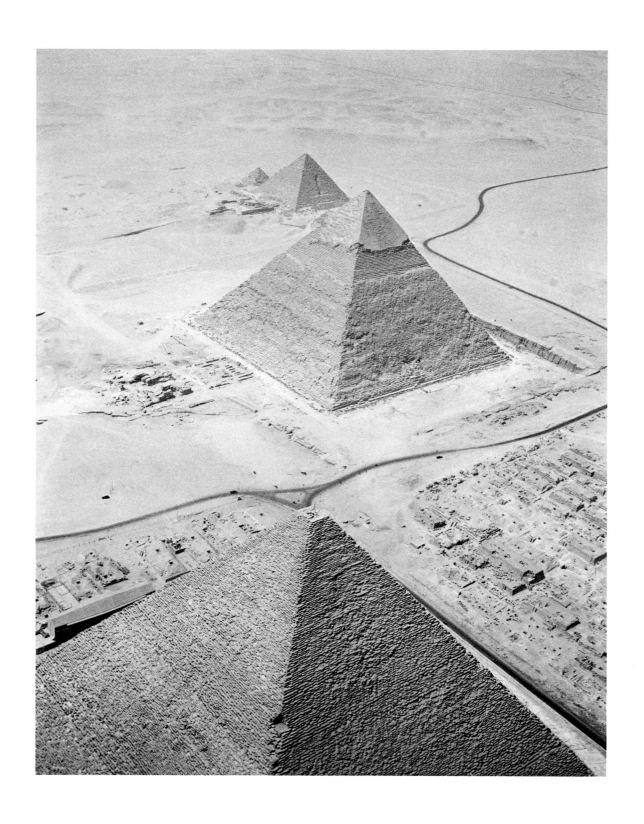

Three Pyramids of Giza
Egypt, 1984, *cat. no. 19*

Archaic Temple
Corinth, Greece, 1984, *cat. no. 24*

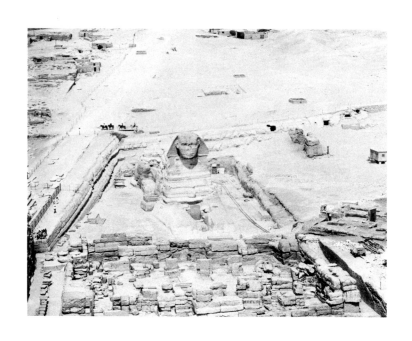

Sphinx (frontal)
Giza, Egypt, 1984, *cat. no. 17*

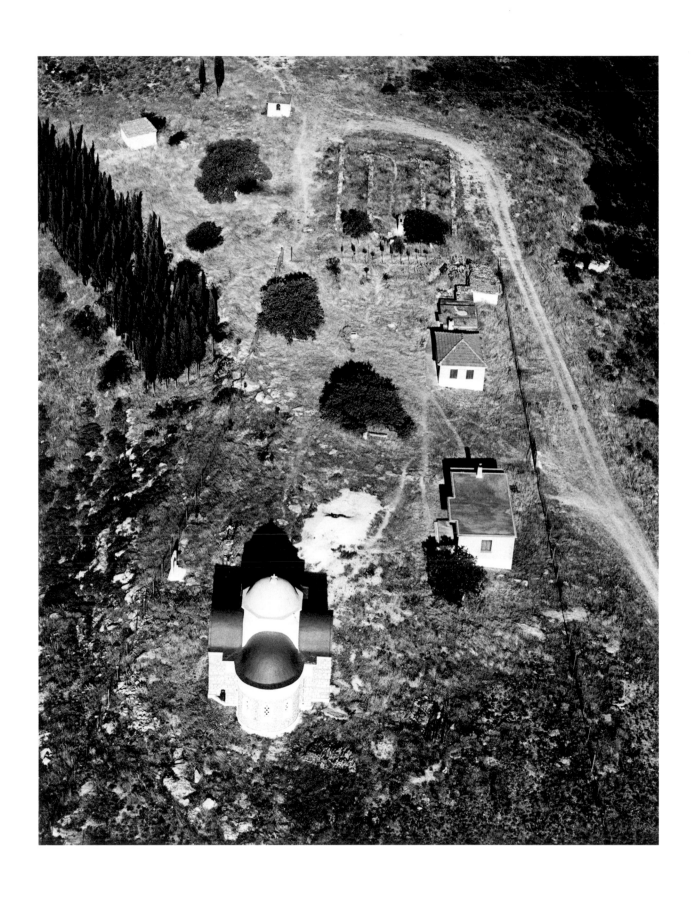

Black-roofed Church
Mykonos, Greece, 1984, *cat. no. 21*

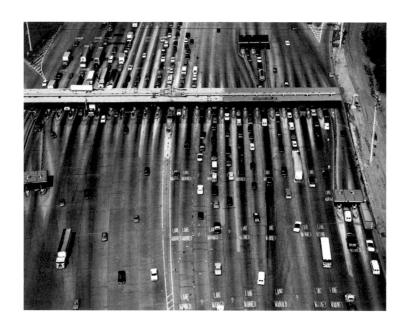

Lane Manned
New York City, 1985, *cat. no. 64*

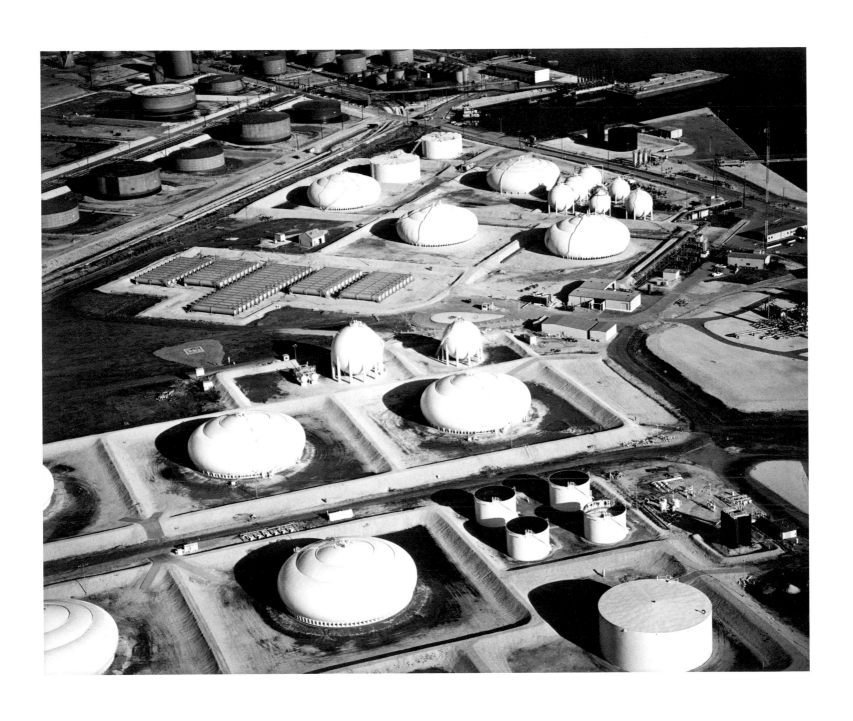

Industrial Cream Puffs
Houston, Texas, 1988, *cat. no. 61*

An Interview with Marilyn Bridges, April 1990

by Anne H. Hoy

Marilyn Bridges–The Sacred & Secular: A Decade of Aerial Photography presents images of seven cultures: Egypt, Greece, Great Britain, the Yucatán, Peru, and North America in ancient times, and today's United States. Is there a message that unites the photographs in this book and exhibition?

How we treat ourselves is visible in how we treat the landscape. We're marring the land, while ancient man was conscious of placing himself in a positive relation to it.

Though I didn't start photographing with environmental issues in mind, I felt man's reverence for the earth 2,000 years ago when I made my first photographs of the Nazca drawings of Peru. I'm not hitting people over the head with it — I want them simply to enjoy my photographs as well. But I feel we should consider the landscape more, for our own sake.

The sacred sites themselves are suffering today. In Greece and Egypt, the monuments are disintegrating, because of the air pollution of cars and industry. In Peru, contemporary writings — graffiti and political slogans — are now side by side with the great Nazca lines. The burning of the Amazon rain forest has changed the climate, increasing rains and flash-flooding, which endanger the lines of Peru. So you see, enviromental pollution affects not only modern man's future but also his past. The photographs of *The Sacred & Secular* can call attention to the need for preservation efforts, to protect the sites against vandalism or harmful land development or just people's carelessness and misuse.

Your first book, Markings: Aerial Views of Sacred Landscapes *and your next book,* Planet Peru *[both Aperture publications] show your fascination with the ancient sites — and among them, the drawings on the Nazca plains. The photographs reproduced in this book show similar early Indian markings in North America, as well as analogous burial mounds here and in Great Britain and sacred monuments in Egypt, Greece and Peru. What attracts you to these places?*

From age 18 on, I was drawn to know what was beyond this life, beyond everyday experience. I was brought up as a Christian, but I had a spiritual drive to know about other religions too. I know there are forces beyond what we're taught. If we can open up to them, there is a lot to be revealed to us. Man today has cut himself off from a lot of understanding. We've boxed

ourselves in. We forget to look at the heavens and the earth to pull in that energy, to realize there are different places in the world where there are centers of energy. The Nazca plains are one of them, the pyramids of Giza in Egypt are another.

There is a theory that the Nazca drawings marked landing fields for extraterrestrials. How do you respond?

The drawings can be seen in their entirety only from the sky, so it's easy to think of them as signals to interplanetary creatures. In *Chariots of the Gods*, Erich von Daniken gave credit to beings from outer space, but more credit should have been given to men on earth, 2,000 years ago. Ancient man not only had the desire to appeal to his gods in this way, but also the technology and know-how to do it. It's hubris, perhaps tainted with racial prejudice, to believe that only modern man or supermen from other planets could do these things. All evidence points to the fact that they were created by Native Americans for ceremonial purposes.

Then man was very much in touch with his environment. He had a sensitivity we may have lost, and was not "primitive" as we think. We've "progressed," but we've lost something. The things we've lost are what I seem to discover — that kinship between ancient man and nature.

A lot of discovery comes from what is left on the land, and there's still much to be found. Nazca, for example, was just rediscovered in the l930s when a pilot happened to fly overhead. People didn't know the drawings were there. So the Pan American Highway was laid through the Nazca pampa and bisects a giant lizard and a lot of other drawings. At least photography offers a way of recording all these things, before they are destroyed....

I am happy that my work helps archaeologists, because it can lead them to sites. They get to see things they wouldn't otherwise. Often their funding won't cover aerial photography.

From Nadar taking his balloon over Paris in 1856 to today's NASA satellite pictures, there have been many aerial photographers. How do you distinguish your work from theirs?

Unlike many aerial photographers, I fly very low, since I am trying to be much more intimate with my subject matter on the landscape. I never paint on my photographs or alter the land itself - my work shows only the lines and objects actually *found* on the landscape. But all our images just happen

to be from a different vantage point from most photographs. That's about all we have in common: we're in the air looking down.

There are differences to be appreciated. I'm not up there making abstract patterns out of the landscape. I'm not making pretty pictures. I attempt to reveal man and his relation to the earth.

The viewer of my photographs goes through an exploration, like mine when I'm flying, of the uncommon vantage point, of this new interpretation of the landscape and the objects on it. Most of my pictures show the landscape and the patterns that man and nature have made upon it over time.

What is your experience of seeing from the air, from what John Szarkowski called "a witch's distance"?

It's much different from glancing down from the window of a commercial jet. You must learn to develop something called "narrow vision," because there's so much information below you. It's important to know exactly what you want to put inside that frame.

Your photographs are rich in data - about history, archaeology, anthropology — and they carry a quiet plea for preservation. Are documentation and advocacy your primary goals?

The sites in my photographs are important to record. But I'm not doing this just for the record or only to bring about change. This is a reflection of the way I feel.

The pictures serve many purposes — art and science, personal response and reportage. It's an immediate response when I'm shooting, because the ground goes by so fast. I discover the feelings I had later, looking at the prints. They convey a sense of a forgotten past, a kind of isolation.

There is a melancholy Romantic tradition in landscape painting that shows contemporary people dwarfed by the remains of lost civilizations, ruined by time and humanity and overgrown by Nature — a tradition that rebukes human neglect and ethnocentricity. Do you feel a part of this landscape tradition?

Yes. There is a melancholy feeling to the photographs, for they show that we have abandoned these vital ceremonial sites and ignore their spiritual power, and we are worse than our ancestors in ruining those remains. The photographs also show how small even superhuman efforts are in relation to the land, and how all cultures have

sought the divine through their markings and constructions.

The constructions are a form of religious communication?

Communication is the word. The pictures I make can serve as evidence of ancient man's desire to reach his gods. But they are also personal responses to the landscape and translations of its spirit into photography in an artful way.

What are some of those artful ways?

There is a sense of the light making sculpture, of painting with light, in the way the photographs are composed. I'm very conscious of the frame, which has amazed some curators, since the plane is moving very fast. I crop very rarely. Most of my prints are full frame. I prefer to work very early and late in the day, when there's a strong clear light, with strong shadows. It makes things strongly dimensional. I can play with the angles and make things seem to pop off the surface. Sometimes the shadows can become as much the subject matter to me as the objects themselves.

Has your work altered over the last ten years?

I see more. My print style has changed especially. It used to be dark, dark, dark. And moody. Now I see more tones, and there's more to see in the photograph itself. I let more elements come into it. But there are no gigantic leaps. It's been one long, slow, growing process. I feel sorry for photographers who have to leap off in wild directions because they feel the need to do something different.

How important is the printing of your work?

I agree with Ansel Adams that the negative is the score and the print is the performance of the symphony. So much can be done in my work with toning, contrast, burning and dodging — rarely is there a straight print. This is intrinsic to my act of photographing under these conditions, and it's also part of the art. You make a photograph with light, and then you make it with light again in the darkroom. You have two chances. The second chance is as important as the first one.

A Wall Street Street Journal *article about you called you "Indiana Jane," and you have just been made a member of* The Explorers Club. *How does this feel?*

It was a great honor, because the Club has few females, and a lot of them are astronauts. My work is exploratory because it involves flying over terrain and finding things people haven't seen, perhaps for centuries, and making photographs that can serve archaeology and anthropology.

It's also an adventure, I get off on it. In fact, I suppose (laughter) I lead a kind of daring, interesting life. I need that challenge.... Just working from a plane in foreign territory is a challenge in itself.

Is challenge necessary to do your best work?

In my work, I'm always on the edge. I'm out there not knowing if I'm going to return, it can be that perilous. Of course, I don't go out taking risks just to feel alive, but there's something splendid about giving your all, letting a part of yourself go. When I photograph, though, I try to be as together as I can. I try to stay in top shape, because I may have to depend on my body, for instance, photographing as I hang out of an open cargo door. There is so much margin for error, you don't want to increase it.

I'll turn back if it's too dangerous. I wanted to photograph Machu Picchu in Peru for a year, but every time I was frustrated. When I finally got up, I was caught between two layers of clouds, at the tip of the Andes. Everything would disappear as the clouds were coming in. The mountains got too close. But after six separate attempts, I finally got the shot.

What you go through doesn't show in the photographs.

No. It's easy to forget or ignore what goes into making most photographs, as well as the ones in this book. A lot of tears and a lot of pain went into mine, in addition to the pleasure.

What are the dangers you face in doing your work?

It's dangerous for me because of my low altitudes, because there's no recovery space if you stall out. There are up-drafts and down-drafts from mountains that will pull the plane down. There's wind shear, which can tear up a small aircraft, and make it drop. Hot and humid weather is dangerous, and at high altitudes a plane doesn't perform as well. Where the air is thinner — for instance, in New Mexico and the Andes — you need longer runways for the plane to perform well enough to even take off.

I've flown with another pilot in single-engine planes over the English Channel, and over the Gulf to get to the Yucatán. The danger of flying over water is that if the engine quits, there's no place to land. If you survive a crash over the Gulf, you don't want to be eaten up by sharks, so we debated buying a life raft or shark bags, which you get into for protection. In the end, we took nothing: the life raft was too heavy, since we had to carry full tanks and other supplies, which took a lot of room. The bags were too expensive....

So this is "not taking risks"?

(Laughter) I didn't know that much then. I've become a lot more cautious.

Has it been tougher being a woman photographer?

In the beginning, it was tougher being a woman aerial photographer. But I overcame this because I became a pilot. Some pilots used to tease me and try to scare me, but respect for my work changed 100 percent when I got my license. To get a pilot's license is

hard — learning navigation, mechanics, and just conquering the fear of putting the plane down. A lot of people never make it....

At RIT (the Rochester Institute of Technology), when I was studying photography, there were not a lot of women. Since I graduated, many more have come into photography, but the field is still male-dominated. Photography, exploration, flying are still mainly male.

What experiences would you share with other women in the field?

I always had to hold my own. I always talked pretty straight. Maybe having two brothers taught me to feel comfortable with men, not to be intimidated. I always thought of men as brothers. I didn't feel subservient in any way. I felt equal. If I felt men were coming on, I would just talk right through it. "What's a good-looking woman like you doing this for?" If you go with this line, you feed it. Don't even give it energy. I talk about my work. I dress neutrally. I keep the focus on being there working.

What advice would you give students who would like to pursue your kind of work?

Doing fine-art photography is very hard. It's not something you can depend on for paying your way through life. If it happens, it's wonderful. Then, if it rains, it pours, but for a long time, it's a drought. You need to have faith in your work and to pick up signals from other people. Listen to criticism, don't repel it. Listen. And take what you need. The biggest problem is being afraid to go out there and hear what people say.

Do you keep a diary? Are there writings, lines of poetry you relate to, are there things written about you that strike a chord?

I've written down, from somewhere, "Where your pain is, is where your work is." Anne Morrow Lindbergh, the wife of the pilot, said much the same. The pain, the fears — from the fears of flying to the fear of getting up to lecture to hundreds of people — I don't like feeling scared, but I have to go through it in order to do this work, and then it feels great.

And what Paul Caponigro has written about my photographs was insightful — I do admire his work.

The photographer Paul Caponigro writes that Bridges's photographs are "curious and mysterious experiences. Like tapestries or mosaics, they are beautiful in themselves to contemplate, but placed in the context of their scale and source, they are powerful gifts from a distant time and psyche. Drawn to the mystery of ancient times and sacred sites, Marilyn Bridges hovers above mythology etched in the land. Bringing back for us experiences of a remote time, her flights give wings to our imagination."

Exhibition Catalog
by Tom Bridges

PERU Ancient Peru did not begin with the Inca Empire, but it did end when the last Inca ruler, Atahuallpa, a captive of the Spanish, was given the choice of being burned alive or, if he became a Christian, being garrotted. He chose the latter and was executed on August 29, 1533.

Peru has been called a cemetery of civilizations — and not without reason. As early as 2000 B.C., the introduction of pottery and corn production on the north coast inspired the rapid growth of local cultures.

Sometime around 1000 B.C., the Chavín culture in the northern highlands was fired with messianic zeal, and spread word of their multi-personality feline god north and south along the Peruvian coast. Chavín interaction with local cultures caused a florescence in the arts.

At Paracas, on the south coast, artist-priests began creating enormous images of gods on hillsides by removing rocks to expose the lighter undersurface. The art of ground-drawing captured the imagination of the Nazca people further south around 500 B.C., and for nearly 1000 years they used the local pampas and plateaus as a sacred canvas for gigantic drawings of zoological creatures, geometric designs, and enigmatic pathways, miles long.

On the north and central coast, various cultures in the valleys of Leche, Lambayeque, Zaña, Chicama, Viru, Santa, and Casma produced distinctive pottery styles. Society was relatively classless, beneath the priesthood, which wielded considerable power. Small pyramids were built, and cultivation was greatly improved by the use of extensive irrigation techniques, such as canals, aqueducts, and channeling.

From ca. 200 B.C., the Mochica people of the north coast slowly expanded their territories, reaching an imperial scale around A.D. 800. Their highly realistic ceramics and large pyramids distinguished them among early Peruvians. The empire saw the reduction of priestly power, the growth of secular government, and the beginnings of a class society. The Mochica were absorbed around A.D. 1250 by the Chimu, whose empire would reach all the northern and central valleys. They built large settlement compounds and achieved true secular government with a central ruler. Society became stratified, the priesthood was demoted, and a large army was developed to realize the expansionist dreams of the ruling nobles.

At about the same time in the southern sierra, tribes began moving north along the coast, and one of them, the Incas, soon achieved dominance. Like the Romans in the speed of their conquest, their administrative genius, and their ability to assimilate other cultures, they produced the greatest empire of the New World, stretching from Ecuador in the north to Chile in the south, before collapsing in the face of a small band of Spanish swashbucklers in the 16th century. Had the Spanish not arrived when they did, during a period of civil war, had Pizarro failed to incite revolution among the subjugated tribes, had the Incas not been so convinced of their invincibility, and had the myth of a "white god" not activated their superstitions and made them so vulnerable, the history of South America would be much different.

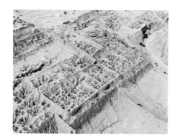

cat. no. 4 **Cerro Purgatorio, Leche River Valley, Peru, 1988**
The extensive ruins of Cerro Purgatorio consist of weathered pyramids, plazas, and densely packed urban compounds eroded into geometric patterns in the Leche River Valley in northern Peru. The ancient population center was part of the Lambayeque culture which flourished between A.D. 1000 and 1450 but survived until the Spanish Conquest. The photograph is a close-up of several elevated urban compounds, each about 300 feet in length. Within the compounds, individual cells (living and storage areas) originally had thatched roofs.

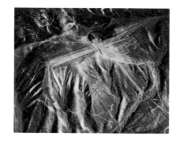

cat. no. 5 **APRA and Arrows, Nazca, Peru, 1989**
Modern political graffiti contrasts with two trapezoidal figures, each nearly a mile long, made by the ancient Nazcas around A.D. 600. The grid alongside the lower trapezoid is composed of one continuous line connecting both trapezoids. Geometric figures are the most numerous drawings at Nazca and interconnected figures often miles apart are not uncommon. These webs of lines and geometric patterns have been explained as ceremonial paths, astronomical sightings, and markers leading to *huacas* (sacred places such as piles of stones and topographical features), as well as fantastic beacons for extraterrestrials. Just above the base of the lower trapezoid is a stylized 150-foot drawing of a shark or killer whale (both important gods in the Nazca pantheon) probably dating to the 3rd century B.C.

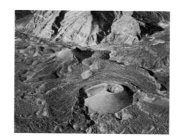

cat. no. 6 **Valley of the Volcanos, Andagua, Peru, 1989**
The lunar landscape of the remote Valley of the Volcanos is approximately 11,700 feet above sea level, northwest of Arequepa in southern Peru. The valley is an open geological

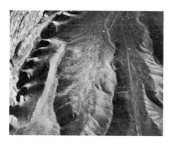

cat. no. 1 **Birdman on Plateau, Nazca, Peru, 1989**
Birds are the most popular motifs among the many figures drawn on the low plateaus and desert floor surrounding Nazca in southern Peru. This 600-foot example, constructed like all the motifs at Nazca by removing a covering of small rocks to expose the lighter earth below, lies on top of a plateau among hillocks skirting the pampa. Here the bird is seen from above as if it were in flight. On its back is what appears to be a human face. The figure was probably first constructed between 300 B.C. and A.D. 100 for still not fully understood reasons. Like all Nazca animal figures, it may have served in clan initiation ceremonies or fertility and agricultural rites, in which participants walked or danced along the outline of the drawings. The figures may also represent constellations as seen by the ancient Nazcas. Some, but not all of them, are oriented to the stars.

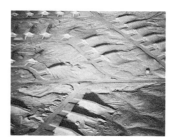

cat. no. 2 **Desert Military Installation, Ica, Peru, 1989**

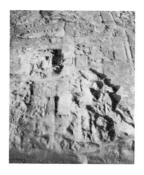

cat. no. 3 **Sand-covered Ruins, Casma Valley, Peru, 1989**
The ruins at this unidentified site in the North Coast's Casma Valley exhibit patterns of pyramids and settlement grids. Extensive pockmarking concentrated to the left of the pyramids is a sign that *huaqueros* (grave-robbers) have pillaged this site.

fault with some 80 small active and extinct volcanos (average height 175-230 feet), which rise above swirls of cooled basaltic lava.

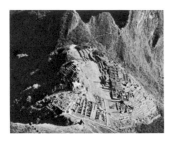

cat. no. 7 Machu Picchu (with Huayna Picchu), Peru, 1989

The "Lost City of the Incas" has lost much of its mystery since Hiram Bingham found it in 1911 in its jungle camouflage , but the 15th-century A.D. citadel-sanctuary is still a magnificent sight. Set on a saddle between two peaks, Machu Picchu and Huayna Picchu, some 8,000 feet above the Urubamba River, the city is a complex of stone buildings, plazas, towers and temples, with surrounding agricultural terracing. Following the Spanish Conquest (1532-33), Machu Picchu was abandoned and did not take part in later Inca resistance which continued until 1572 when last Inca chieftain was captured and killed. Huayna Picchu is the mountain peak directly above the ruins.

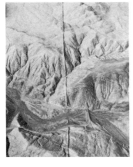

cat. no. 8 Great Wall of Peru, Santa Valley, Peru, 1989

The Great Wall (now in segments) stretches some 46 miles through the Santa River Valley in northern Peru, from the Pacific coast to the rising elevation of the Andean spurs. Originally believed to be of Inca origin, its stone and adobe construction is now attributed to the local Santa culture, dating perhaps from A.D. 650 to 900. The purpose of the wall is unknown. As a defensive barrier, its maximum height of seven feet would hardly have deterred the armies of ancient Peru, which often boasted 40,000 warriors who travelled over mountains and deserts to battle enemies. Recent theories suggest that the wall might have been a commercial, population, or administrative boundary.

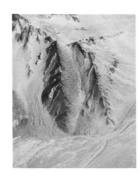

cat. no. 9 Ray God and Cat, Ica, Peru, 1989

Human-like figures are pre-Nazca in origin and probably date from interaction between Chavín and Paracas peoples around 500 B.C. The motifs are almost always found on hillsides, and are less sophisticated in technique and much smaller in size than their Nazca relatives. The "human" figure here has a headdress with emanating rays, symbolizing earthly or celestial power. The feline, just below the "human," represents the jaguar god, a Chavín export from northern Peru that was almost universally accepted in the country because it could take on the attributes of regional gods. Despite this kitty's cute appearance, the feline god was generally bad-tempered. Both figures are about 60 to 70 feet in size.

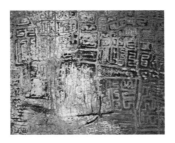

cat. no. 10 Ancient Irrigation (computer tapestry), mid-North Coast, Peru, 1989

The Peruvian coastal desert is cut by rivers fed by Andean ice and snow. The valleys of these rivers were the cradles of ancient Peru's civilizations. Because of infrequent rain along the coast, the ancient Peruvians depended on river water to irrigate their crops. Over the centuries, they devised elaborate canal systems, underground conduits, aqueducts, and elevated plots of land surrounded by channels. The photograph shows a section of the vast geometric network of elevated plot irrigation along the mid-North Coast.

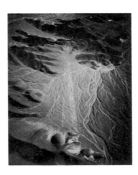

cat. no. 11 Pathway to Infinity, high overview, Nazca, Peru, 1988

"False trapezoidal" figures are common drawings in the Nazca area. Instead of the body of a figure being cleared away, two lines, each about three feet wide, appear to converge and form a trapezoid; in fact, the lines extend for miles until they are lost in the foothills of the Andes. It has been suggested that this type of figure might have been used in coming-of-age or clan initiation ceremonies and that "walkers" would experience the sensation of growth or shrinking depending on the end of the figure at which they began their walk. The false trapezoidal figures are believed to date to the Late Nazca Period, between A.D. 600 and 900.

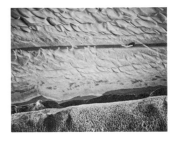

cat. no. 12 Sand Dunes with Truck on Coastal Pan American Highway, near Chala, Peru, 1989

Yucatán

The rise and fall of Maya civilization remains a puzzle. The ruins of Guatemala, Belize, Honduras, El Salvador and eastern Mexico mark its ancient domain.

Between ca. 900 B.C. and A.D. 200, the people we call the Maya began their rise to civilization by clustering in groups, developing agricultural technology, and centralizing their political and social structure. The Classic Period, ca. A.D. 200 to 900, saw the rapid expansion of older settlements and the growth of new ones. A florescence of building took place as centers of population such as Tikal, Copán, and Palenque became complexes of palaces and pyramids, surrounded by the thatched-roof huts of the peasants.

The Maya were ruled by hereditary nobles in a society in which ancestry and lineage were of primary importance. Toward the end of the Classic Period, in Yaxchilán and other lowland sites, warlords grew in esteem as the Maya suffered intense internal and external conflicts.

According to Maya scholar Charles Gallenkamp, the Maya had no equal in pre-Columbian American astronomy, calendrics, hieroglyphic writing, and mathematics. They had a highly accurate calendar based on careful measurements of the solar year, and astronomers could chart the movements of the sun, moon, and Venus, and predict lunar eclipses.

Early in the 9th century, virtually all the splendid cities in the southern lowlands were abandoned. The reason for the decline is not yet understood, although war, revolution, and natural disasters have all been suggested. Almost simultaneously, the northern Yucatán underwent a revival of culture under Mexican, primarily Toltec, influence. Here, Chichén Itzá became a great city of power and culture until ca. A.D. 1250. After this period, Maya cohesion broke down, and petty chieftains concerned with warfare and commercial trade ruled their own fiefdoms.

The Maya believed in the integration of all phenomena — physical and spiritual - in the cosmos. They were convinced of the cyclical creation and destruction of the earth and mankind, and held that the world in which they lived began in 3114 B.C. That world ended in 1517 when the sweep of the Spanish Conquest began to engulf the Maya civilization.

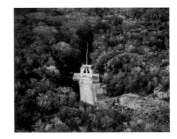

cat. no. 13 Archway, Kabáh, Yucatán, Mexico, 1982

Kabáh was a small Classic Maya center that flourished in the Puuc Hills of northern Yucatán between A.D. 600 and 950. During this time a paved, elevated causeway, some 15 feet wide, was constructed between Kabáh and the city of Uxmal, about ten miles away. The part of the causeway that led into Kabáh was highlighted by an arch that has been restored.

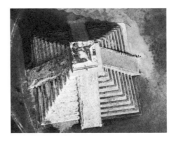

cat. no. 14 Castillo from the Perpendicular, Chichén Itzá, Yucatán, Mexico, 1982

Although the great Maya city of Chichén Itzá probably dates from the 5th century A.D., much of the major building took place under Toltec occupation between A.D. 900 and 1200. The Castillo, believed to be dedicated to Kukulcán, the legendary Toltec leader (deified as Quetzalcóatl), rises some 80 feet from a 190-foot square platform. The pyramid has nine terraces of regularly diminishing size, giving it the appearance of greater height. Four grand staircases (two restored) lead to a platform crowned by a temple. Stairways divide each side into 18 sections, symbolizing the 18 months of the Maya calendar year,

with 91 steps on each side for a total of 364 days (one extra day was allowed for the structure on top).

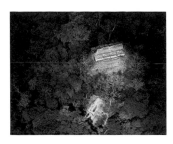

cat. no. 15 Temple 33 and Temple 20, Yaxchilán, Chiapas, Mexico, 1982

Yaxchilán was a major Maya center along the Usumacinta River in central Yucatán from about A.D. 600 to 900. In the 8th century A.D., when temples 33 and 20 were probably built, Yaxchilán was ruled by the militant Jaguar Dynasty. Temple 33 (upper right), with a roof-comb which runs the full length of the building, has three doors that lead to a single chamber. The building, atop a steep hill, was reached by a stairway of stepped terraces, a portion of which has been restored in front of the temple. Temple 20 is the small set of ruins below Temple 33.

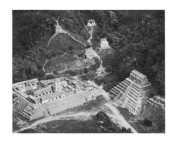

cat. no. 16 Overview, Palenque, Chiapas, Mexico, 1982

Palenque was a major Maya ceremonial center in western Yucatán from A.D. 600 to 800, and its building flourished between A.D. 633 and 692 during the reigns of Lord Shield Pacal and his son Chan-Bahlum. The view in the photograph faces the southeast and shows approximately 240,000 square yards. In the upper left, on a rising elevation, are from left: the Temple of the Cross, with its collapsed facade but intact roof-comb; the Temple of the Foliated Cross, so-called because of an interior bas-relief displaying a cross growing from a god-head; and the Temple of the Sun, named after the sun god, depicted within as the jaguar god of the underworld. All three were dedicated in A.D. 692. In the foreground (left), is the Palace Complex, a complicated network of buildings, vaulted galleries, patios, courtyards, and subterranean chambers, covering an area of about an acre. To the right, the Temple of Inscriptions stands on a 75-foot, eight-stepped platform. Built between A.D. 672 and 682, its subterranean burial chamber held the sarcophagus of Lord Shield Pacal until it was excavated in 1952.

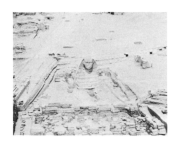

cat. no. 17 Sphinx (frontal), Giza, Egypt, 1984

The Great Sphinx, much weathered by time and sand, still guards King Khafre's pyramid at Giza. Built during the Fourth Dynasty (ca. 2613 to 2498 B.C.) out of a spur of rock left over from the quarrying operations of the pyramid, it is 240 feet long and 65 feet high. Sphinxes are composite animals with a lion's body and the head of a falcon, ram, or human. The Great Sphinx is a lion couchant with a human head, possibly representing King Khafre. Unlike the generally hateful and enigmatic female sphinxes of Greek mythology, the sphinx in ancient Egypt was usually male and a symbol of royal power, protective toward the king's subjects but terrible to his enemies.

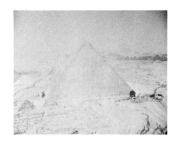

cat. no. 18 Spirit Pyramid, Giza, Egypt, 1984

The Great Pyramid of Khufu, second king of the Fourth Dynasty (ca. 2589 to 2566 B.C.), is veiled by a cloud of sand in the large mortuary complex of Giza. Although now devoid of its capstone and sheathing, it reaches some 480 feet in height, making it the tallest of the three main pyramids at Giza. According to the Greek historian Herodotus, it took 20 years and 100,000 men to complete. Within its structure, of local Tura limestone faced with red granite are, a king's chamber, a queen's chamber, and a spectacular Grand Gallery, some 160 feet long and 26 feet high, as well as access stairways. Like all temple architecture of ancient Egypt, the pyramid is oriented to the four cardinal directions, with its entrance on the north side. Surrounding auxiliary structures, enclosed by an exclusive wall, included a mortuary temple, a small valley temple, a causeway and various shrines. In ancient Egypt, Khufu's tomb was know as the "Pyramid which is the Horizon."

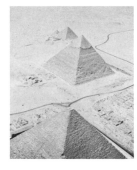

cat. no. 19 Three Pyramids of Giza, Egypt, 1984

Although the transition from stepped to smooth-sided pyramid was not as revolutionary as the leap from the rectangular mastaba tomb to the pyramid shape in the Third Dynasty (see cat. no. 20), the three great pyramids of Giza, built during the Fourth Dynasty, represent the apex of pyramid construction. In the foreground is the Great Pyramid of Khufu (seen closer up in cat. no. 18). The second pyramid in this sequence is that of Khafre, ca. 2558 to 2532 B.C., brother and successor to Khufu. It stands some 470 feet high but is built on higher ground so that it often appears to be larger. Like all the pyramids at Giza, it is made of local limestone faced with red granite. The third pyramid, rising 216 feet, is the smallest of the three and was built for Menkure, ca. 2532 to 2504 B.C. Known as the "Divine Pyramid," it was finished by his son Shepseskaf. The small pyramid to its left is the tomb of one of Menkure's queens.

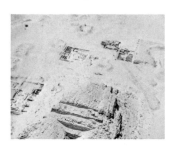

cat. no. 20 Pyramid in the Sand, Saqqara, Egypt, 1984

This unfinished stepped pyramid of the Third Dynasty (ca. 2686 to 2613 B.C.), the so-called "Buried Pyramid," has been ascribed to Sekhemkhet, whose reign lasted only about six years, ca. 2649 to 2643 B.C. Sekhemkhet was the immediate successor to Zoser, during whose reign the stepped pyramid evolved from the early mastaba tombs. The mastaba tomb is an excavated substructure divided into a series of rooms and a central burial chamber on which was built a mud-brick superstructure. On top of the superstructure, a four-stepped pyramid was first constructed; this was later expanded to the final shape of six steps or levels. The royal tomb was contained in the original square base built almost entirely of stone. Surrounding the pyramid was a group of auxiliary buildings. It is believed that Sekhemkhet's pyramid was to rise to seven levels and some 230 feet in height.

Egypt In the ancient Egyptian pantheon, the sun god Re was associated with seasonal change and the rise and fall of the Nile, and each evening, it was believed, he passed from the living world into that of the dead, only to re-emerge unscathed in the morning. One of Re's progeny, Osiris, gained prominence among his siblings. After being killed and dismembered by his brother, Seth, his parts were scattered throughout the Nile basin. Isis, their mother, reassembled his pieces, and he lived on as king of the underworld. Given these two beliefs, it is not surprising that the ancient Egyptians were obsessed with life after death.

These beliefs became the state religion in the Fourth Dynasty (ca. 2613 to 2498 B.C.), following the unification of the kingdoms of Upper and Lower Egypt around 3000 B.C. by Menes (Narmer). In its unified form, Egypt expanded its territories and trading partners. Its boats sailed the Mediterranean as far as the Black Sea and Gibraltar, and in the Red Sea, they passed through the Gulf of Oman and into the Indian Ocean.

From at least the beginning of the Early Dynastic Period (ca. 3050 to 2686 B.C.), the Egyptians ritualized their belief that man was composed of flesh and spirit and that the spirit was capable of remaining alive if the body were preserved and attended by proper ceremonies. From this time, burials became the focus of elaborate mortuary procedures, and the dead were placed in deep pits and provided with an assortment of items to enable the spirit to continue its life in an acceptable manner. The pits were filled in and often covered with a mound of earth. Eventually, the simple excavated burial chamber evolved into the mastaba tomb - a rectangular substructure divided into numerous compartments and a central burial chamber, on top of which a superstructure was built. At the beginning of the Third Dynasty (ca. 2686 to 2613 B.C.), King Zoser (ca. 2668 to 2649 B.C.) instigated the construction of the first pyramidal tomb, a six-level, stepped structure built on top of a mastaba tomb base. This style was altered by King Khufu (ca. 2589 to 2566 B.C.), when the smooth-sided pyramid form was adopted.

The era of great pyramid building continued to the end of the Sixth Dynasty (ca. 2345 to 2181 B.C.), when the Old Kingdom was undermined by ineffectual rule.

Greece

Just as Atlas, the mythological hero, supported the heavens for incalculable eons, so the art, literature, philosophy, politics, and architecture of ancient Greece have supported Western civilization into modern times.

The ancient Greeks borrowed and refined as much culture as they created. Their country's central location in the eastern Mediterranean opened them to Eastern influences; this, and the impact of the customs of polyglot northern invaders, provided the basis of what is considered Classical Greece.

Early civilization in the Aegean, highlighted by Minoan culture, gave way to Mycenean dominance on the mainland of the Peloponnese around 1500 B.C. Agamemnon and other Mycenean heroes, their battles and fortresses, would be given a lasting place in literature some 700 years later by Homer. Dorian invaders from the north leveled Mycenae ca. 1150 B.C., beginning the Greek "Dark Ages," a period of petty wars and little cultural growth. Finally, around 750 B.C., ancient Greece reversed its cultural decline with the growth of city-states, such as Corinth, Argos, and Athens, and a renaissance of literature, art, and philosophy. Around 27 B.C., ancient Greece came to an end when Roman conquerors incorporated it into the province of Achaea.

In flying over the stark landscape of the Peleponnese and the Cyclades, Marilyn Bridges retraced the path of the mythical Daedalus across the Aegean to the mainland. She photographed the tracings of present and past civilizations, and commented: "Although often beautiful as abstract forms, modern-day sites do not conform to the ancient Greek vision of spiritual placement. There is no sense of grand design, as was the case with the old. There is no longer continuity with the heavens. Ancient man celebrated his unification with the spiritual with lavish temples and shrines. Modern man seems to identify his isolation with oil refineries and stacked cities."

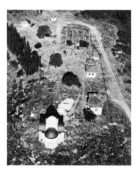

cat. no. 21 **Black-roofed Church, Mykonos, Greece, 1984**

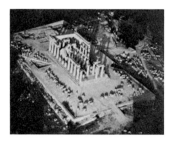

cat. no. 22 **Aphaia Temple, Aegina, Greece, 1984**
The island of Aegina was named after the mother of the hero-king Aiakos, son of Zeus and grandfather of Achilles and Ajax. The island reached its greatest prosperity in the 7th century B.C. The Aphaia Temple dates from ca. 500 B.C. and is the oldest temple in Greece proper whose colonnade still stands. It is believed to have been dedicated to Aphaia, a localization of the Cretan goddess Britomartis, a friend of Artemis. The temple stands on a terrace (approximately 216 feet by 131 feet), and was built of local limestone. Its colonnade once had 36 columns. Parts of the interior walls and inner columns have been restored.

cat. no. 23 **White City, Kea, Greece, 1984**
Kea was the birthplace of the lyric poets Simonides and Bacchlides. The island's small villages hug the hills, leaving the lower terrain to farming and grazing. Little remains of Kea's ancient cities, many of which were destroyed when the island of Thera (Plato's "Atlantis") erupted in the 15th century B.C. and partially sank into the sea.

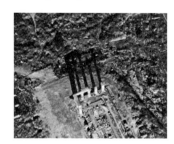

cat. no. 24 **Archaic Temple, Corinth, Greece, 1984**
In Greek drama and legend, Jason and Medea lived in Corinth after being forced into exile from Iolcos. This was the home of Sisyphus and his grandson Bellerophon, and it was here that Oedipus was reared by King Polybus. A rich city in ancient times, Corinth was completely destroyed by the forces of the Roman consul L. Mummius in 146 B.C. Most of the city's ruins date to the Roman period; its Greek remains are hidden under the rubble. One notable exception is the mid-6th century B.C. Temple of Apollo, here seen from the perpendicular. Seven adjacent columns of the Doric temple are extant. Surrounding the temple were markets, shops, and various smaller temples, including possibly the shrine of Hera Akraia, associated with the cult of Mermerus and Pheres, the slain children of Medea.

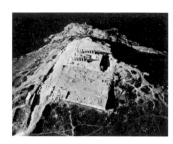

cat. no. 25 **Temple of Poseidon, Sounion, Greece, 1984**
When the ancient Athenians rounded Cape Sounion, crowned by the Temple of Poseidon, at the southern tip of Attica, they knew they were safely home and protected under the aegis of Athena and her uncle Poseidon. The Doric temple dates to ca. 444 B.C. Byron carved his name on the north anta of the east porch, and also wrote: "Place me on Sunium's marbled steep, where nothing but the waves and I, may hear our mutual murmurs sweep: There, swanlike, let me sing and die."

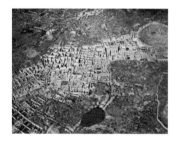

cat. no. 26 **Theatre and Sanctuaries of the Foreign Gods, Delos, Greece, 1984**
In Greek mythology Leto gave birth to Apollo and Artemis on Delos, and from at least 2000 B.C., the island was a religious center. It was purified in 426 B.C. when all graves were removed and it was proclaimed that no one could be born or die there. The Romans arrived in 250 B.C. and turned Delos into the largest slave market in the Aegean. The early 3rd-century B.C. theater once held some 5000 spectators. Houses surround the theater. To the upper right is the House of the Masks, which may have been a hotel for visiting actors. The Sanctuaries of the Foreign Gods (top) comprised shrines to the Egyptian god Serapis, the Syrian gods Adad and Atargatis, and various lesser deities.

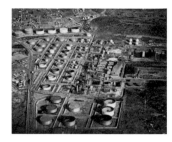

cat. no. 27 **Oil Refinery, Aspropirgos, Bay of Eleusis, Greece, 1984**

cat. no. 28 **Swimmers, Gulf of Nauplia, Greece, 1984**

Britain

From earliest times some Britons have looked upon the land as a living entity, to be shaped and rearranged with sensitivity. Believing that the sky and earth are an integrated body pulsing with life-force, they built structures according to a predetermined scheme of criteria - such as the four cardinal directions and linear arrangements of prominent features on the earth's surface. But the criteria remain mysterious: in a given generation only a few wise men (shamans, Druids, Merlins, and the like) were entrusted with such powerful secrets.

The earthen burial mounds (or barrows) and megalithic tombs of the Neolithic Period, from about 4000 to 2000 B.C., appear to be aligned with certain topographical features, and many are oriented along a north-south axis. It is possible that these early structures served as models for the stone circles and henges (large circular areas of placed stones or earthen embankments enclosing one or more stone circles) built between 3000 and 1200 B.C.

Both stone circles and henges were constructed with careful alignment and orientation, but mortuary rites do not appear to be their primary function. Stone circles were probably used for religious ceremonies and possibly for solar observation. Henges such as Stonehenge and Avebury are complex, monumental megalithic structures, requiring extraordinary planning and labor to construct, and must have had special significance for ancient Britons, perhaps serving as regional centers for religious ceremonies. Certain rock alignments within the structures suggest they were used for solar observance.

Today more than a thousand stone circles, as well as hundreds of henges, barrows, hill forts, and other prehistoric structures, remain extant in Britain - often surrounded by well-worked fields. Superstition, no doubt, has helped protect them, but it has taken a determined effort by many Britons to preserve what remains.

The ancient Britons, like several Indian groups of the New World, used the landscape as a canvas for drawing. The Cerne Abbas Giant and the Uffington Horse are two of a number of enormous hill figures, including 18th- and 19th-century commemorative creations, made by removing the soft turf and exposing the chalk undersurface. Maintained over the years, they remain exquisite documents of man's positive imprint on a fragile but generous landscape.

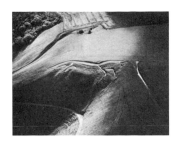

cat. no. 29 **Uffington Horse, Oxfordshire, England, 1985**

This wonderful steed stretches some 365 feet in a full gallop on the Berkshire Downs. Its impressionistic rendering resembles that on coins of the Belgae, a Gallic people who moved to Britain from the Continent around 300 B.C. The figure, made by removing turf from the chalk undersurface, was probably first cut between 100 B.C. and A.D. 100, and if it is Gallic in origin, it might have marked a site sacred to a horse deity. In popular tradition, it is associated with the charger of Alfred the Great, who was born in nearby Wantage in A.D. 849 and defeated the Danes in 871 at the Battle of Ashdown, fought near here. The horse was cared for over the centuries by a ritual scouring which took place every seven years during Whitsuntide (the week beginning the seventh Sunday after Easter). It is presently maintained by the government.

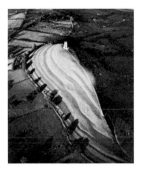

cat. no. 30 **Glastonbury Tor, Somerset, England, 1985**

The area around Glastonbury was once a watery marsh with islands of high land, one of which was the mythical Avalon of the Arthurian legends and the repository of the Holy Grail, brought to England by Joseph of Arimathea. Here also Arthur and Guinevere are said to be buried, near the ruins of the old Glastonbury Cathedral. The most prominent feature on the landscape is Glastonbury Tor, which rises 130 feet over what is now drained, cultivated land. The top of the Tor has been the site of numerous structures, including a pagan temple, a chieftain's stronghold, a Saxon church, and finally the 14th-century St. Michael's Church, whose tower alone survives. The Tor's ridges may be the remains of a pagan and early Christian ritual spiral path which circled the hill seven times to the summit.

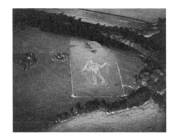

cat. no. 31 **Cerne Abbas Giant, Dorset, England, 1985**

The giant chalk figure demands respect against this slope of down, his huge crab-tree club raised to strike, yet his origin and identity remain a mystery. According to local legend, a real giant was once killed on Trundle Hill and the people from Cerne marked the spot where he fell by outlining him. Probably, the figure is Celtic-Roman in origin, perhaps dating 100 B.C. to A.D. 200, and could represent the Celtic god Helith or his Roman counterpart Hercules. The giant stands 180 feet tall, measures 44 feet across the shoulders, and carries a 120-foot club. His erect penis is 30 feet long (not surprisingly, since Hercules had 50 wives and his issue was prodigious). Through the centuries, barren women who wished to conceive often spent the night within the outline of the giant's penis. It was also believed that the fecundity of the local herds and fields depended upon the preservation of the hill figure, and, as a result, the giant's lines are said to have been scoured every seven years on a lunar cycle for 66 generations.

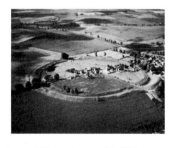

cat. no. 32 **Avebury with Silbury Hill, Wilshire, England, 1985**

Avebury's great earthwork and stone circles were constructed by Neolithic and Bronze Age Britons probably in four stages between 3000 and 1500 B.C. The large outer trench and Great Circle of stones (once numbering about 100, with some stones weighing up to 60 tons) has a diameter of over 1200 feet. The diameter of the inner circles (now largely destroyed) is some 320 feet. Modern roads now run through its four entrances. Much of the destruction of Avebury's symmetry occurred in the 18th century when stones were removed or crushed to clear the land for cultivation. Although some stones appear to have been aligned for lunar and solar observance, the main purpose of the complex is thought to have been ceremonial, perhaps for community seasonal rituals.

Silbury Hill (top, right) is the largest man-made hill in Europe, reaching 130 feet in height, covering some five and a quarter acres, and containing a million cubic yards of chalk and stone. It is believed to have been created in four stages, beginning in ca. 2500

B.C., and to be the burial place of King Sil, interned on horseback. Excavations so far have revealed no burial remains. One theory is that Silbury might have been some sort of astronomical observatory.

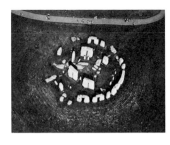

cat. no. 33 **Stonehenge #1, Wiltshire, England, 1985**

Probably the most famous megalithic structure in the world, Stonehenge is believed to have been built in stages between 2800 and 1550 B.C. (although some theories would date it 1000 years earlier). It was apparently a multi-purpose construction, with lunar and solar observations relating to seasonal events of primary importance. It also served as a place of burial and probably as a central ceremonial complex for observation of the equinox and solstice. The Druids' association with Stonehenge is speculative, and if true at all, certainly occurred late in its history, as they do not appear in Britain before 250 B.C.

This overview focuses on the central core of Stonehenge. The outer, Sarsen Circle, about 100 feet in diameter, once consisted of 30 upright stones, weighing some 25 tons a piece, and capped by a continous ring of 30 lintels weighing about seven tons each. Inside were five Sarsen trilithons, each consisting of a pair of huge uprights up to 45 tons in weight, which were capped by a massive lintel. The walkway (top) is a recent addition to the site to prevent its destruction by souvenir and graffiti vandals.

Native Americans
The centuries-old view of the American Indian as either a marauding warrior or a noble savage does not hold up to modern scrutiny. Complex Native American societies evolved in patterns similar to those of peoples in Europe, Asia, and elsewhere. While regional differences were significant, most native population centers developed as a result of food/water sources, commercial alliances, and frequently because of religious practices.

Throughout North America, dynamic native cultures developed and faded before the arrival of the Europeans. And while we are left with only traces of these people, some of their architectural achievements survive. The pueblos of the Southwest, the earthen pyramids of the Southeast, and the effigy and burial mounds and earthworks of the Midwest differ in construction and intent, but all are integrated with the environment. To the Native American builder, a structure did not sit upon the land, but arose from it, from roots deeply placed in the soil.

Starting sometime around 1000 B.C. and spreading throughout the Ohio River Valley, the Adena culture developed highly complex burial practices that included the building of enormous burial mounds for communal interment. The Hopewell culture (ca. 100 B.C. — A.D. 700) elaborated on these customs by carrying their well-defined social hierarchy to the grave, accompanied by numerous burial objects and ceremonies which confirmed social distinctions in nature and the spiritual world. They developed a network of alliances for the exchange of mortuary and other goods throughout the area east of the Mississippi, and built monumental ceremonial earthworks in which to perform their rituals and govern their society.

In southern California and Arizona, the earth was also linked to the ceremonial practices of various Native American tribal groups living along the Lower Colorado River Basin. Beginning around 1000 years ago and continuing to almost modern times, shaman priests made gigantic drawings of supernatural heros and mythical monsters on the river terraces. It is likely they used the figures in ceremonies appealing to the celestial powers for aid in war, against drought, or the like. Though often crude in execution, these drawings were probably intended to represent the perfection of the whole—the balance of the spirit and the material.

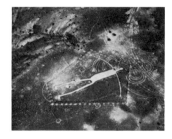

cat. no. 34 **Ha-ak, Blythe Site #1, Blythe, California, 1982**

This 170-foot "human" intaglio was created by removing the gravel covering of the desert pavement to expose the lighter subsoil, which constitutes the image. The figure is a female (a gravel furrow once indicated female genitalia, but this was destroyed and replaced with male genitalia in this century); its extended belly is further evidence of its female sex. Created by Mojave or Pima shamans between A.D. 1000 and 1500, the drawing may have depicted Ha-ak, a monster that devoured children, which was destroyed by Mastamho, the creator god. Near its feet is a cleared circle with thin arms radiating toward the four cardinal directions. The intaglio measures 90 feet in diameter and might have been used as a healing site during Paleo-Indian occupation some 2000 to 4000 years ago. Vehicles seriously damaged the figure before it was fenced in by the U.S. Land Management Bureau.

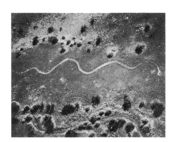

cat. no. 35 Parker Rattlesnake, Parker, Arizona, 1983

This 156-foot-long serpent has been rendered realistically with a forked tongue. Although the drawing is an intaglio, it has several sets of stone rattles and two quartz eyes. The effigy could represent Ahii-quir, a sacred serpent person in local Mojave legend. It is also an almost exact duplicate of the Hopi Snake Clan motif. A faint trail crosses the rattles and is oriented toward an important water hole (a snake motif is often associated with water sources and rain). The figure is believed to have been made by Mojave shamans about 200 years ago.

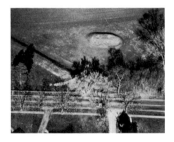

cat. no. 36 Mound, Newark, Ohio, 1983

Burial Mound of the Hopewell Culture, Middle Woodland Period, 200 B.C. to A.D. 100.

cat. no. 37 Winterhaven Stick Man, Winterhaven, California, 1983

The "stick man" is an 80-foot intaglio with the shape of its legs lightly tamped in. Local Indian groups suggest that it represents Kwa-you, a demon that stalked the Lower Colorado Basin, yet its resemblance to Hopi kachina motifs is unmistakable. The figure might be Mojave or Cocopath in origin and may date to the 15th century A.D. Below the stick man is a probable healing site in the form of an intaglio interwoven cross, whose four arms correspond to the four cardinal directions. Its origin and dates are unknown.

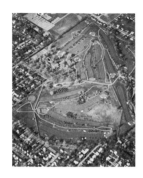

cat. no. 38 Newark Earthworks, High Overview, Ohio, 1983

The Octagon State Memorial and Mound Builders Monument preserve about 190 acres of the original four square miles of this ceremonial settlement of the ancient Hopewell people. The present site includes a nearly perfect octagon (foreground), with 300-foot-long earthen walls and a small burial mound opposite its eight entrances. It is attached by a ten-foot-high set of parallel walls to a perfect circle enclosure encompassing some 20 acres. The site was occupied from about 100 B.C. to A.D. 400, a period of extensive trade and political and cultural exchange among natives throughout the country east of the Mississippi. The white lines are part of the 18-hole Newark Country Club golf course, which is contained by the earthworks.

cat. no. 39 Conical Mounds, Iowa, 1983

Around A.D. 650, following the decline of the influential and stabilizing Hopewell culture, the practice of molding earth into conical, linear, and effigy mounds became common to certain Indian groups living in the present states of Iowa, Wisconsin, and Minnesota. These people, linked by social beliefs that disavowed the Hopewellian practice of differentiating groups by social strata, buried their dead in mounds not exceeding three feet in height and with widths (or diameters) of 20 feet and lengths of 70 feet. The uses of round or linear shapes often represent beliefs in positive and negative forces in nature, and circular and linear formations can act as a seal against intrusion. To increase their visibility, the mounds were temporarily outlined with agricultural lime for this photograph.

cat. no. 40 Shaman Intaglio, Lower Colorado Basin, California, 1983

This figure is some 40 feet tall and at least 500 years old. Because of the effigy's long phallus and bent knees (both symbols of fertility), it is believed to represent a tribal shaman, and could have been used in healing and coming-of-age ceremonies. The mottled area within the fenced-off enclosure might have resulted from a ceremonial hopscotch dance sequence, the purpose of which is not known. The figure is endangered by vehicles maintaining the power lines.

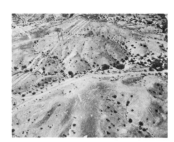

cat. no. 41 Serpent Mound, Ohio, 1982

This is the largest effigy mound in the world, an embankment of rocks and earth, over 1300 feet in length, 20 feet wide and four feet in height. The serpent's jaws are open, about to seize an oval object (a slightly elevated earth mound some 158 feet long and 79 feet across, and said to symbolize an egg). Its tail is in a triple coil. The Serpent Mound was built by the Adena people for unknown ceremonial purposes between 1000 and 300 B.C.

American Landscapes

Marilyn Bridges sees all landscapes as historical documents, shaped and reshaped by elemental forces and marked and manipulated by humanity. The land is our route to our primal origins and fixes our relationship to the cosmos.

Intimacy with the landscape is lost if it is seen from too high. Distance can beautify it; manmade scars can become balanced shapes. But closer to the earth's surface, Bridges reveals how creations of contemporary man contrast with those of nature. Unnatural constructions pierce the rhythmic contours of the land.

Bridges's photographs of today's North America offer vistas of an eclectic landscape: winding roads and decaying barns exude a sense of rural isolation; the tracks of cattle on the prairie suggest how the West was really won; baseball diamonds and backyard swimming pools are the prizes of suburbia; windmill farms and natural gas tanks stand as endorsements of alternate energy sources, while automobile graveyards and billboards romanticizing cigarette-smoking bear witness to a culture's self-destructiveness.

Bridges remarks, "I wish to show the subtle symbols that man creates unintentionally in the environment. Through the markings and objects he leaves on the landscape, he reveals his relationship with the earth. In contrast, in my photographs of Monument Valley and Mount St. Helens, the untouched grandeur and awesome power of nature minimize man's traces on the landscape by comparison."

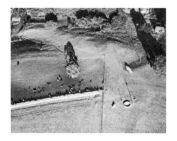

cat. no. 42 Feeding Cattle, Petaluma, California, 1986

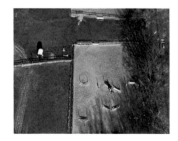

cat. no. 44 The Equestrian, Mendon, New York, 1986

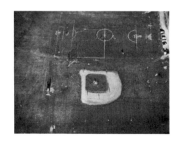

cat. no. 43 Playing Baseball, Allens Creek, New York, 1986

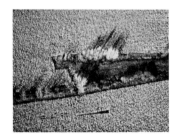

cat. no. 45 Tweed Field, Le Roy, New York, 1981

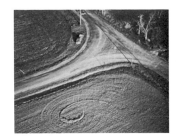

cat. no. 46 **Road, Avon,
New York, 1980**

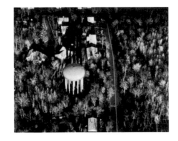

cat. no. 47 **Water Tower,
Spring Valley, New York, 1980**

cat. no. 48 **Yin Yang Pool,
Caledonia, New York, 1981**

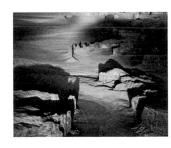

cat. no. 49 **Journey, Monument
Valley, Arizona/Utah, 1983**

cat. no. 50 **Navaho Hogan,
Monument Valley,
Arizona/Utah, 1983**

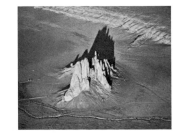

cat. no. 51 **Spires, Monument
Valley, Arizona/Utah, 1983**

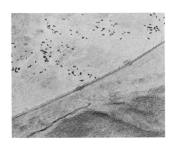

cat. no. 52 **Buffalo in the Badlands,
South Dakota, 1984**

cat. no. 53 **Cattle Trails, Quartz
Mountain, Oklahoma, 1987**

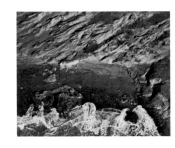

cat. no. 54 **Spirit Surf, Big Sur,
California, 1988**

cat. no. 55 **Swirl, Mount St.
Helens, Washington, 1981**

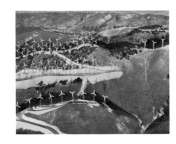

cat. no. 56 **Windmills on Ridges,
Tehachapi, California, 1986**

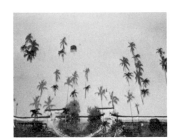

cat. no. 57 **Palm Trees, Miami,
Florida, 1987**

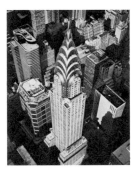

cat. no. 58 **Chrysler Building,
New York City, 1988**

cat. no. 59 **If You Smoke,
New York City, 1985**

cat. no. 60 **Statue of Liberty (back),
New York City, 1985**

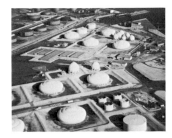

cat. no. 61 **Industrial Cream Puffs,
Houston, Texas, 1988**

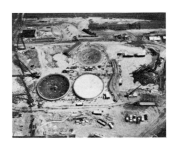

cat. no. 62 **Circles Along the
Hudson, New York City, 1985**

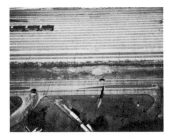

cat. no. 63 **Houston Train Tracks,
Houston, Texas, 1988**

cat. no. 64 **Lane Manned, New
York City, 1985**

cat. no. 65 **Farmhouse,
Le Roy, New York, 1981**

Biography

Born: New Jersey, 1948; BFA 1979, MFA 1981, Rochester Institute of Technology; licensed pilot, single and multi-engine land and sea aircraft.

Awards and Honors
Guggenheim Fellowship 1982, CAPS Grant 1983, National Endowment for the Arts Grant 1984, Fulbright Grant 1988-89, Makedonas Kostas Award (Greece) 1989. Elected fellow of The Explorers Club 1988.

Photographic Books
Markings: Aerial Views of Sacred Landscapes. New York: Aperture, 1986. (Paperback edition: 1990.) Essays by Maria Reiche, Charles Gallenkamp, Lucy Lippard, Keith Critchlow.

Marilyn Bridges–The Sacred & Secular: A Decade of Aerial Photography. New York: International Center of Photography, 1990. Essay by Vicki Goldberg. Interview by Anne H. Hoy.

Planet Peru. New York: Aperture, 1991.

Selected Public and Corporate Collections
Addison Gallery of American Art, Phillips Academy, Andover, MA
American Museum of Natural History, New York
Bibliothèque Nationale, Paris
Canadian Centre for Architecture, Montreal
Center for Creative Photography, University of Arizona, Tucson
Chase Manhattan Bank, New York
Cincinnati Art Museum
Citibank, New York
Graham Nash Collection, Los Angeles
High Museum of Art, Atlanta
International Center of Photography, New York
International Museum of Photography at George Eastman House, Rochester, NY
Library of Congress, Washington, D.C.
Merrill Lynch, Pierce, Fenner & Smith, New York
Metropolitan Museum of Art, New York
Museum of Art, University of Oklahoma, Norman
Museum of the City of New York
Museum of Fine Arts, Houston
Museum of Modern Art, New York
Oriental Photo Distributing Company, Huntington Beach, CA
Philadelphia Museum of Art
Readers Digest, Pleasantville, NY
Royal Commission on Historical Monuments, London
Salt River Project, Phoenix, AZ
Seagram Collection, New York
Union Bank of Finland, Helsinki

Selected Lectures
The Art School of Cuzco, Peru, 1988
Museum of Contemporary Photography, Chicago, IL, 1988
The Explorers Club, New York, 1988
Esalen Institute, Esalen, CA, 1988
Tampa Museum of Art, Tampa, FL, 1987

Catskill Center for Photography, Woodstock, NY, 1987
San Francisco Art Institute, 1987
Burden Gallery, New York, 1987
Smithsonian Institution, Washington, D.C., 1984
Friends of Photography, Carmel, CA, 1983
International Center of Photography, New York, 1983
New York University, New York, 1982
Boston Museum of Fine Arts, MA, 1982
Center for Inter-American Relations, New York, 1982

Selected Workshops
Appalachian Environmental Arts Center, Highlands, NC, 1989
Photographic Resource Center, Boston, MA, 1988
Columbia College, Chicago, IL, 1988
Catskill Center for Photography, Woodstock, NY, 1987
Oklahoma Summer Arts Institute, Quartz Mountain State Park, 1987
XVème Rencontres Internationales de la Photographie, Arles, France, 1984

Exhibition Juror
Juror (with Larry Fink),"New Developments," The Catskill Center for Photography, Woodstock, NY, 1986

Selected Solo Exhibitions
1991
Fine Arts Center at Cheekwood, Nashville, TN

1990
International Center of Photography, New York
Albrecht Art Museum, St. Joseph, MO
Gibbes Art Gallery, Charleston, SC
XXIème Rencontres Internationales de la Photographie, Arles, France
Houston Foto Fest: Houston Museum of Natural Science, TX
University of Kentucky Art Museum, Lexington

1989
Palm Springs Desert Museum, CA
Museum of Revolution, Beijing, China
Municipalidad de Miraflores, Lima (exhibit travelled throughout Peru)
Enoch Pratt Free Library, Baltimore, MD

1988
Sheldon Swope Art Museum, Terre Haute, IN
The Photographers' Gallery, London
Allen Memorial Art Museum, Oberlin College, Oberlin, OH
Etherton Gallery, Tucson, AZ

1987
Canton Art Institute, OH
Forum Fotogalerie, Tarragona, Spain
Lehigh University, Bethlehem, PA
Tampa Museum of Art, FL
Bacardi Gallery, Miami, FL
Oklahoma Art Center, Oklahoma City
Overseas Press Club, New York
International Museum of Photography at George Eastman House, Rochester, NY
Burden Gallery, New York

1986
Light Impressions Spectrum Gallery,

Rochester, NY
Wilderness Park Museum, El Paso, TX
Adler Planetarium, Chicago, IL
Wichita Falls Museum and Art Center, TX

1985
Modulo Galerie, Lisbon and Porto, Portugal
Galerie Junod, Lausanne, Switzerland
Orlando Science Center, FL
Hunter Museum of Art, Chattanooga, TN
Art Museum of South Texas, Corpus Christi
Ken Damy Photogallery, Milan, Italy
Edwin A. Ulrich Museum of Art, Wichita State University, KS
Sheldon Memorial Art Gallery, University of Nebraska, Lincoln

1984
Strecker Museum, Baylor University, Waco, TX
Nikon Foto Galerie, Zurich, Switzerland
Foto Biennale, Enschede, Holland
XVème Rencontres Internationales de la Photographie, Arles, France
Picker Art Gallery, Colgate University, Hamilton, NY
Smithsonian Institution, Washington, D.C.
Sioux City Art Center, Sioux City, IA

1983
Tucson Museum of Art, AZ
Canon Gallery, Amsterdam, Holland
New York Academy of Sciences, New York
Glenbow Museum, Calgary, Canada

1982
The Photographers' Gallery, London
Robert Klein Gallery, Boston
Center for Inter-American Relations, New York

1981
Blue Sky Gallery, Center for Photographic Arts, Portland, OR
MFA Gallery, Rochester Institute of Technology, NY

1980
The Photography Gallery, Philadelphia, PA

1978-79
American Museum of Natural History, New York

Selected Group Exhibitions
1990
Museum of Fine Arts, Houston: "Money Matters: A Critical Look at Bank Architecture," travelling exhibit

1989
University of Oklahoma Museum of Art, Norman: "The New Expeditionary Photographer"
Gallery at the Plaza, Security Pacific Corporation, Los Angeles: "Mystical Objects, Sacred Places"
Richmond Art Center, Richmond, CA: "Off Site: Artists in Response to the Environment"
Robert Koch Gallery, San Francisco: "Around the World in 60 Days"
10th Annual Festival of Photography,

Montpellier, France: "La Plage Photographique"
Philadelphia Museum of Art, PA: "Contemporary Photography: Recent Acquisitions"
Belgian Cultural Center, Paris: "Le Choix des Sens," travelling exhibit

1988
Harvard School of Design, Cambridge, MA: "Aerial Views of the Landscape"

1987
New York State Museum, Albany: "Diamonds are Forever: Artists and Writers on Baseball," travelling exhibit
Triennale, Charleroi, Belgium: "L'Image de l'Architecture"
North Dakota Museum of Art, Grand Forks: "Skyborne: Aerial Photography"

1986
University Art Museum, University of New Mexico, Albuquerque: "The Maya Image in the Western World: The View in Western Art"
Etherton/Stern Gallery, Tucson, AZ: "Visions of the West," travelling exhibit
American Center, Brussels, Belgium: "American Women Photographers"

1985
Burden Gallery, New York: "Western Spaces," travelling exhibit
São Paulo Biennial, Brazil: "Between Science and Fiction"

1984
Bibliothèque Nationale, Paris: "La Photographie Créative"
XVème Rencontres Internationales, Arles, France: "Le Territoire"

1983
The Photographers' Gallery, London: "The View from Above: 125 Years of Aerial Photography," travelling exhibit
Brattleboro Museum & Art Center, VT: "Land Imprints: Ritual Sites and Images Drawn in the Earth"
Friends of Photography, Carmel, CA: "Mount St. Helens, The Photographer's Response"
Evergreen State College, Olympia, WA: "Living with the Volcano," travelling exhibit

1982
Museum of Modern Art, New York: "Contemporary Photography: Recent Acquisitions," travelling exhibit
American Museum of Natural History, New York: "Star Gods"

Writings about the Artist
"Above the Mounds: A Photographic Portfolio," *Timeline* (Ohio Historical Society), vol. 5, no. 3 (June/July, 1988), pp. 24-31.

Ahlgren, Calvin. "Ancient Portraits in the Dust," *The San Francisco Chronicle,* May 17, 1987.

Bogre, Michele. "Marilyn Bridges: Landscapes with Emotion," *Industrial Photography,* vol. 39, no. 2 (February, 1990), pp. 24-29.

"Bridges Through Time," *SAVVY,* (July, 1987).

Bridges, Marilyn. "From the Balcony of the Gods," *Américas,* vol. 36, no. 2 (March/April, 1984), pp. 8-15.

Brown, Robin W. "Earthworks: The Aerial Photography of Marilyn Bridges," *Camera 35,* vol. 26, no. 12 (December, 1981), pp. 52-59.

Connor, Linda. "Review of *Markings: Aerial Views of Sacred Landscapes,*" *Parabola,* vol. 12, no. 2 (May, 1987), pp. 112-114.

Cowley, Geoffrey. "Ancient Icons," *The Sciences,* vol. 27, no. 2 (March/April, 1987), pp. 52-57.

Damy, Ken. "Marilyn Bridges," *Progresso Fotografico* (Italy), (February, 1984), pp. 60-67.

Donegan, Rosemary. "Review of *Markings,*" *Photo Communiqué* (Canada), (Summer, 1987).

Dunas, Jeff. "Marilyn Bridges," *Darkroom Photography,* vol. 11, no. 12 (December, 1989), pp. 30-41.

Edwards, Owen. "Exhibitions: Marilyn Bridges," *American Photographer,* vol. 5, no. 4 (October, 1980), pp. 21-22.

Gerber, Judith. "Abstracting Artifacts," *Afterimage,* vol. 8, nos. 1 & 2 (Summer, 1980), pp. 34-35.

"Glyphs for the Gods," *Mystic Places.* Alexandria: Time-Life Books, 1987. Pp. 128-137.

Goldberg, Robert. "The Indiana Jane of Landscape Photography," *Wall Street Journal,* April 23, 1987.

Harrison, Helen A. "Sacred Peru Seen From Air," *The New York Times,* March 13, 1988.

"Hovering," *Manipulator* (Germany), no. 10 (Spring, 1987), pp. 2-4.

"L'aire des Dieux," *Café crème* (Luxembourg), no. 12 (Summer, 1989), pp. 32-38.

Livingston, Katherine. "A Stone's Throw from Heaven," *American Photographer,* vol. 18, no.3 (March, 1987), pp. 24-25.

Manchester, Ellen. "Visions of the West," *Artspace,* vol. 2, no. 4 (Fall, 1987), pp. 22-27.

"Marilyn Bridges," *Nikon World,* vol. 17, no. 3 (Fall, 1984), pp. 14-21.

"Marilyn Bridges," *Photography Annual 1980-81,* pp. 30-35.

"Marilyn Bridges: Flight Over an Unknown Earth" (interview by Felicia C. Murray and commentary by Pierre Borhan), *Clichés* (Belgium), no. 13 (February, 1985), pp. 12-23.

Miller, Chris. "Review of *Markings,*" *European Photography* (Germany), no. 30 (Spring, 1987).

Mystical Objects, Sacred Places. Introduction by Mark Johnstone. Commentary by Amy Gerstler. Los Angeles: Security Pacific Corporation, 1989. Pp. 1, 2, 13.

Pitts, Terence. "Tracings of Power," *Artweek (*December, 1983).

Raynor, Vivian. Review of "Markings" exhibition. *The New York Times,* April 13, 1987.

"Riddles in the Sand," *Discover,* vol. 3, no. 6 (June, 1982), pp. 50-57.

"Sacred Sanctuaries, Secular Views," *Clichés* (Belgium), no. 48 (July, 1988), pp. 24-31.

Swinnen, Johan M. "Marilyn Bridges," *Foto* (Holland), no. 6 (June, 1983), pp. 26-31.

The New Expeditionary Photographer. Commentary by Carol Beesley, Jon Burris, E.J. Deighton. Norman: University of Oklahoma Museum of Art, 1989. Pp. 5-10.

"Western Spaces," *Aperture,* no. 98 (Spring, 1985), pp. 60-63.

Books Illustrating Bridges's Photographs
Amerikaanse en Nederlandse fotografie. Enschede (Holland): Foto Biennale Enschede, 1984. Pp. 10, 56.

Carley, James P. *Glastonbury Abbey.* Suffolk (England): Boydell & Brewer, Ltd., 1988. Pp. 2-3.

Craven, George M. *Objects & Image: An Introduction to Photography.* Englewood Cliffs: Prentice Hall, 1990 (third edition). P. 191.

Construire les Paysages de la Photographie. Commentary by Jean-Francois Chevrier, Jean-Marc Poinsot, Michèle Chomette. Metz (France): Metz pour la Photographie, 1984. Pp. 20, 38-39, 70.

Johnson, Buffie. *Lady of the Beasts.* New York: Harper & Row, 1988. P. 31.

Lippard, Lucy R. *Overlay.* New York: Pantheon, 1983. P. 137.

Martin, Rupert, ed. *The View From Above.* Commentaries by Robert Doty, Rupert Martin, Ursula Powllys-Lybbe, Ken Baird, H.J.P. Arnold. London: The Photographers' Gallery, 1983. Cover. Pp. 45, 47.

"On the Beach," *Camera International,* no. 19 (Spring, 1989), pp. 44, 47.

Paysages. Lille (France): Festival de Lille, 1986. P. 67.

Peterson, Natasha. *Sacred Sites.* Chicago: Contemporary Books, 1988. Pp. 42, 44.

Rubin, William, ed. *Primitivism in 20th Century Art.* 2 vols. New York: Museum of Modern Art, 1984. Pp. 663-668.

Troisième Triennale Internationale de la Photographie. Charleroi (Belgium): Musée de la Photographie, 1987. Pp. 132, 133, 213.

Marilyn Bridges is represented by Felicia C. Murray, New York City.